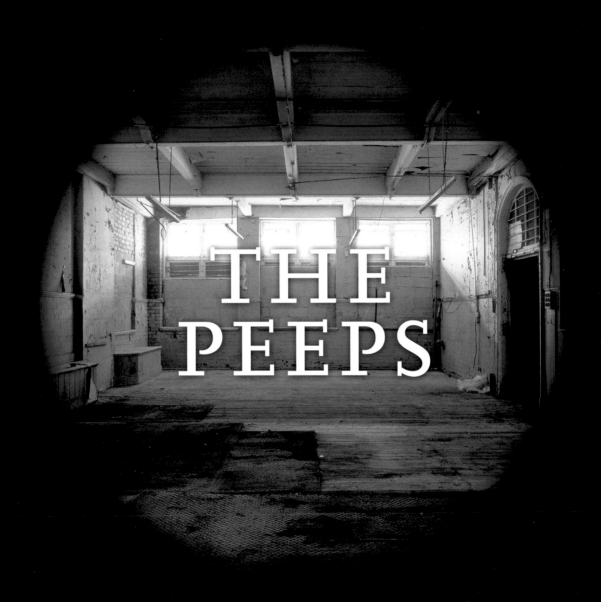

THE PEEPS

Ancoats:
the presence of absence

Dan Dubowitz

MANCHESTER UNIVERSITY PRESS

The Presence of Absence

Ancoats, in Manchester, England, was once unimaginably different. The centre of the world's cotton industry and its first industrial suburb, it was dark and dense, insanely noisy, frenetic, violent, productive, inventive, creative, poor, unhealthy, hard and vibrant. It had a striking vapour, sound and feel. Ancoats had a very different role in the world than the one it has now and will have tomorrow. These artworks have emerged from the experience of this presence and absence.

As part of the regeneration of Ancoats new streets, pavements, civic spaces have been laid down. The Peeps and the Cutting Room Square are part of this project and have been permanently built into this public realm.

The Peeps

Built into the fabric of the buildings, the brass peep holes offer a fleeting glimpse of a walled-in space; a tunnel, a disused toilet, a spinning governor, a bell tower, a gauge. The Peeps are something that you might stumble across as you pass through the streets of Ancoats.

The Cutting Room

The Cutting Room Square is the centrepiece of the new public realm for Ancoats: the first public square ever to be built in the area. It is oriented around 5 towering photographs of the former cutting and pattern rooms of the adjacent Royal Mills. This cutting room speaks both of what Ancoats has been and what it is becoming.

In 2002, when the Ancoats area of Manchester was better known as a formidable wasteland, I was commissioned to contribute to its regeneration. Over the next eight years a series of Peeps, viewed from the streets, were walled up in the buildings of Ancoats and the area's first public square, The Cutting Room, was made.

In immuring charged spaces the Peeps project reveals how what is latent in Ancoats can actively shape its emerging identity as it is remade. These 'redevelopment' projects started out with photography and lead to the concrete and permanent Peeps and Cutting Room artworks as the new Ancoats began to emerge.

This book presents these two projects in the context of the place, its people and the Ancoats stories that formed the inspiration and basis of these works. It makes no attempt to describe or explain these artworks, as there is no definitive explanation to be had. The artwork has emerged out of a wealth of influences from personal and written histories, experiences, ideas and images. They are the confluence of many fragments and the connections and reconnections they make. This book sets out to reflect this working process. It explores how a place might achieve a continuity of culture as it passes through a period of abandonment, dereliction and regeneration, and dwells on how an artist might constructively be involved in shaping a city.

Dan Dubowitz, Ancoats, 2011

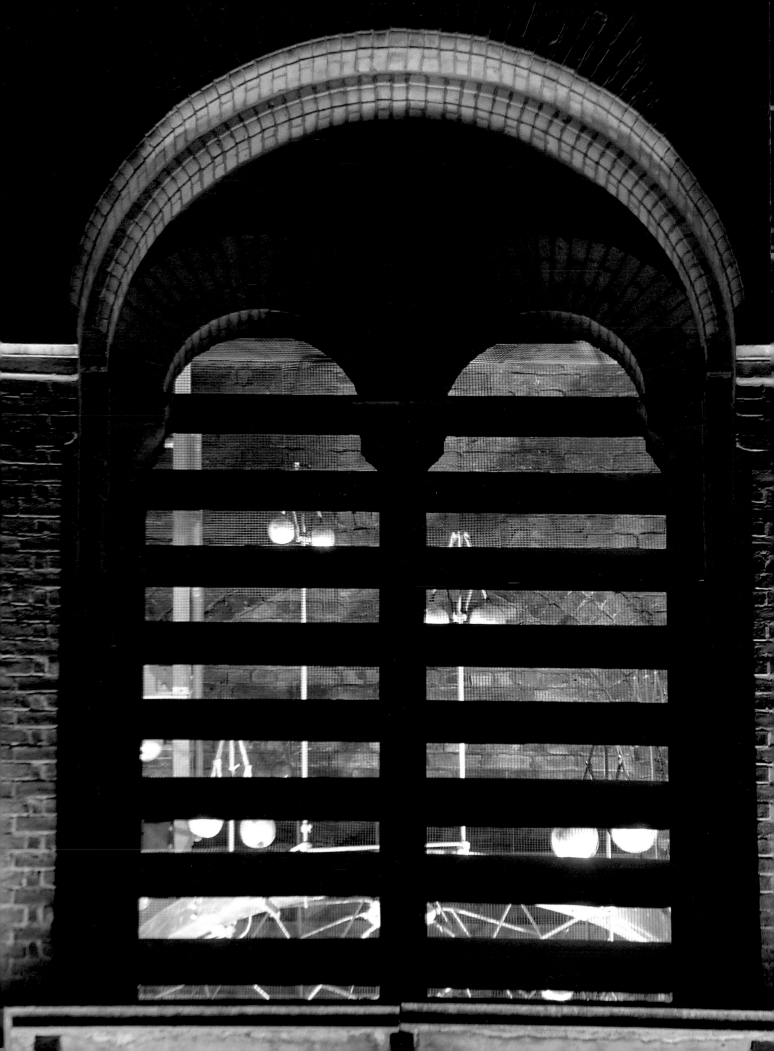

THE PEEPS: CONTENTS
The Presence of Absence

C. R.

Ward Bdy.

ST. CLEMENT WARD

TRAMWAY

GREAT ANCOATS STREET

Obelisk

1874

TRAMWAY

1891

NOR

H

foreword

I first met Dan Dubowitz in 2003 when I opened an exhibition on the platforms at Piccadilly Station. When I asked what it was about, I was told it included a series of images of derelict buildings. I have to say I was a bit sceptical that advertising decay on a grand scale was a good idea, how would that help regeneration? This was before I saw the images he had produced. Chatting to Dan after the opening, he explained that he was just starting out on his work in Ancoats and after that I must admit I was looking forward to seeing what he would do next. Later I read a comment, I think it was in The Times, that the Ancoats exhibition was the best free art show running in the UK.

This book tells the story of Dan's journey through Ancoats and the artworks he produced as a consequence. He began by recording stories and photographing the fabric of Ancoats and from them he created the exhibition at Piccadilly Station, a website and a book. He went on to produce his peepholes throughout the buildings and streets of Ancoats. His latest work, The Cutting Room, has become the focal point in this part of the city.

Dan brought a fresh pair of eyes to Ancoats, he helped us to see both the latent potential and the cultural history that resonated in these buildings on the cusp of transformation and in the process, he helped Manchester re-engage with it.

Sir Richard Leese
Leader, Manchester City Council
February 2011

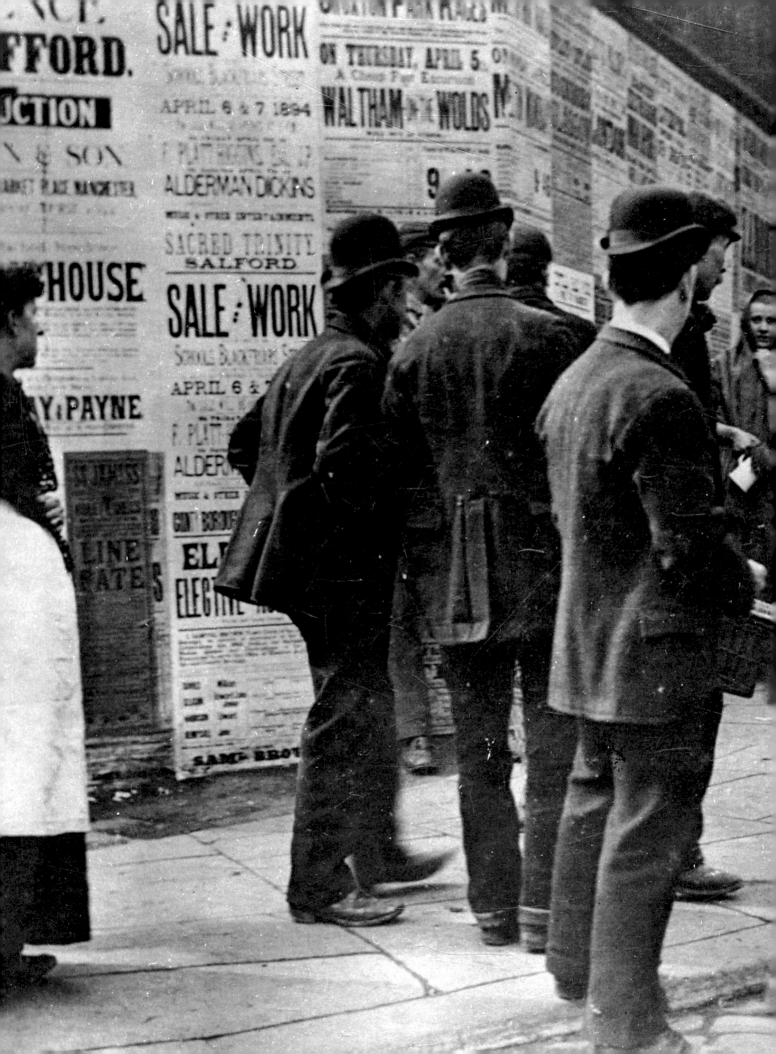

"...over my dead body are you building that sculpture"

<u>the subtle art of cultural masterplanning</u>

Ancoats, Manchester's first industrial suburb, reflects the fortunes of the City that first shaped it – in its heyday, the world price of spun cotton was set by the all powerful mill owners of Redhill Street. The quality of their product was unrivalled and the need to remain at the top of the game provided the incentive to embrace new technologies to increase efficiency and keep costs down. As the world markets for cotton matured and changed, so too did the fortunes of those businesses that had once dominated world markets. Mill development ceased in the early 1900s and by the 1950s the production of spun cotton had all but vanished. From the '50s to the '80s the rag trade occupied the mills, but over time, they mostly closed down or moved on.

The final nail in the coffin for the Ancoats mills came from a strange source – Manchester's first Olympic bid. Several of the building owners decided they would make more money selling vacant buildings for the Olympics than by receiving rents, so the businesses were turfed out, losing both jobs and informal caretakers in the process. When the bid eventually failed, the mills were left abandoned and their decline accelerated. Back in the '60s the many residents were moved out of the area in a slum clearance programme, leaving it with a fraction of its population and areas of cleared land. Ancoats became synonymous with images of decay, dereliction, crime and abandonment.

Not only was Ancoats itself an investment free zone, it cast a long shadow on neighbouring areas, including what was then the outer fringe of the city centre. Given the City's ambitions to grow and connect with its immediate suburbs, connecting local people to jobs, amenities and the opportunities that were emerging in the City, it became imperative that something be done to arrest and reverse the fortunes of Ancoats.

In 1989 Ancoats was designated a Conservation Area. Even after the ravages of arson and dereliction had taken their toll, in the mid '90s this part of Ancoats still boasted a high concentration of listed buildings – all of them on English Heritage's list of the 100 buildings most at risk in the UK. In parallel with the City realising that something should be done, local people and others committed to the rescue of historic fabric, also felt the need to take more direct action to save what was left of the area's heritage. In 1996, the City came together with those groups and two organisations were formed: the Ancoats

Urban Village Company and the Ancoats Buildings Preservation Trust, the former a company, the latter a charitable trust, providing opportunities to tap into both public/private investment and charitable funding.

I joined the Ancoats Urban Village Company (later subsumed into New East Manchester) in 1998 to oversee the regeneration of the area. We were faced with highly fragmented ownerships (in excess of 200 across 50 acres) including a substantial number of overseas, and therefore absentee, owners.

The vision was relatively simple: we wanted to reverse the decline and regenerate the area as an extension to the City, containing a vibrant mix of uses. We wanted to create an attractive place to live, work and visit; to safeguard, protect and enhance the built heritage and promote a sustainable, diverse and integrated residential and business community. The strategy we developed to help deliver this vision centred around 3 main actions: renewal of the public realm; removal of uncertainty through bringing land ownerships together (ie Compulsory Purchase Order); and guidance of development and investment through the production of Supplementary Planning Guidance.

This book deals with the transformation of the public realm, in particular how the inclusion of art and an artist as an integral element, influenced and enriched the process, as well as the end result.

Why is the public realm so important?

I was first awakened to its influence for good or ill in the late '80s when I worked on the redevelopment of Hulme, one of Manchester's first big physical and socio-economic regeneration projects. The '70s redevelopment that had promised so much, failed, in part because the residents became disconnected with their own neighbourhoods and no longer felt the streets and spaces between buildings were theirs to use and enjoy. As a consequence, their engagement in the redesign of their area began with a fortress mentality, wanting high walls and fences that would have left the streets and spaces desolate, bereft of passive supervision as well as any sense of belonging… neighbourhood…place. The battle to reclaim the streets and spaces often waged long into the night!

Around this time, I visited Barcelona and was deeply impressed both with the quality of the public realm and how art had been used within it to uplift the spirit. I came away with the feeling that Barcelonians walked at least 2 inches taller as a result of the pride they had and the joy they felt just being out on the streets of their city. I wanted to bring this sense of place and belonging to Ancoats.

Easier said than done, where do you start? I knew how to assemble a team that

could design and build stuff, but I didn't have the first idea about engaging, or engaging with, an artist. I took the easy way out and started with the safe ground of assembling the landscape architect, engineer and QS and told them that I wanted art in Ancoats to be a key part of the process and that they should "sort out how to do it". They sensibly responded with a competition based on a brief to produce a design for a canal side space in the area. There were some crossed wires about that brief, I had intended to use the ideas simply to choose the artist we wanted to work with, the team thought we would use that winning idea to deliver a piece of work:

> [*Enter stage left, Dan for his first real discussion with me after being selected*]
>
> DAN I'd like to talk to you about cultural masterplanning
>
> [*Lyn putting a hand up to stop him talking*]
>
> LYN Before you go any further, over my dead body are you building that sculpture
>
> DAN Good, that's a relief, I think we really need to do something completely different here
>
> [*Lyn, wind taken from her sails*]
>
> LYN Oh....right, good....erm.

You get the picture. We talked some more and we both realised that no amount of talking was going to get us to a point where we would find the answer there and then, to what art should be in Ancoats, so I told Dan to go away and get under the skin of the place and then come back with his idea(s).

We didn't stop talking, that's impossible for Dan, he is irrepressible and he collects people and things at a rate of knots I have never before encountered.

> LYN Dan, what is all that stuff in your studio and why do you always walk about with a camera?
>
> DAN It's how I get to know a place, I'm completely manic and this is the only thing that makes me stand still and really take things in – the stuff well, if I didn't grab it, it was heading straight into a skip.

Boy oh boy did he get under the skin of the place and the people.

> [*Some time later, Dan enters (stage left again)*]
>
> LYN Hi Dan, so what are we going to do then?
>
> DAN Something subtle
>
> LYN Subtle?

DAN Yes subtle, something you have to stumble across...discover...

LYN Fantastic! I like subtle...

The design team were already passionate about the work they were doing, Dan increased that passion through his enthusiasm and his desire to include the whole team in his approach to delivering art as an integral part of Ancoats' renewal. For me, it harked back to the traditional spirit of Manchester as a place of innovation and invention, the team became tighter and more committed to making Ancoats a place that people could and would love. So, against the backdrop of 14 listed buildings, a designated Conservation Area, a vociferous heritage lobby (including potential World Heritage status), a limited budget and lots of people with very strong opinions, Dan did his stuff...

So, What is Cultural Masterplanning then?

(Me? I know nothing about art, but I know what I like...)

The conversation Dan tried to have with me when we first met, became a recurring topic between us over the years and I'm not sure that we have concluded even now, exactly what it means. Like art itself, it's a difficult thing to pin down.

We had a clear intention from the outset that art would be embedded into Ancoats as public investment was rolled out, but quite how this would be achieved, we had no idea. It would have been easy to wallow in the past in a way that would not have connected to the present, but we needed to recognise and celebrate the fact that Ancoats continues to have a life that is every bit as relevant as what has gone before. Arguably, the role of a Cultural Masterplanner is to ensure that in re-making places the threads of culture that provide a sense of place and belonging are drawn through to connect old and new. The form that may take will vary from place to place.

So how do we pin it down and work out whether art is value for money and delivers real benefit? The mechanisms used to measure, monitor and appraise don't really adapt well to measuring art and culture, yet we ignore the importance of culture in society at our peril. In the current economic climate when choices are pretty stark, the argument that "it's the economy stupid" is difficult to gainsay, but our response to addressing that issue can choose to recognise that alongside some of the instant fixes, the slow burn of embedding a cultural dimension to what we do, will help in so many ways to ensure that the quick fixes don't burn themselves out leaving no lasting benefit.

Lyn Fenton

From "England's green and pleasant Land" to the
"dark, Satanic mills"

These familiar words from Blake's poem Jerusalem were probably
inspired by the Albion Corn Mill in London, not far from his home.
However they strike a chord with the highly detailed descriptions of
Manchester written by Engels and others some decades later. Blake's
words voice concern for the social cost of the industrial revolution.
Indeed urbanisation and industrialisation brought enormous change
to living and working conditions.

Early textile workers lived and worked in their own cottages, using
their own tools, a range of work skills and at their own pace. While
life may not have been easy for textile craftsmen, there would often
have been opportunity for, particularly rural, families to grow some
vegetables, perhaps keep chickens or raise a pig. There was, relatively
speaking, space and the means to cook food and keep clean. Perhaps
not exactly Blake's "England's green and pleasant Land", but a long
way from the life of their successors, the mill workers.

Concentrating production in one place, the mills brought workers
together to largely unsanitary and overcrowded towns. Home and
place of work was separated. The premises and machinery were
owned by the employer. The machines set the pace and the owners
the length of the working day. Work patterns changed, marked not
by the completion of a task, but by the completion of a set period
of time. Division of labour was highly rigid, to keep costs down and
control quality, meaning that one person would do only one element
of the process of production. That and the increasing sophistication
of machinery effectively deskilled and devalued workers' talents.
By paying women and children less than men they were drawn into
production and some families, as Engels decried, were "turned
upside down" leaving the men at home to "sit around" caring for
young children. At the beginning there were no health and safety
regulations, and the mills were noisy, hot and often very dangerous.

Slowly the government responded to anger at the conditions under
which, particularly children, worked and lived, and from fear of
disease, particularly cholera. And slowly working conditions, a
minimum age, working week, and public health measures were
introduced, tempering the worst of conditions within and outside the
mills and other factories of the Victorian age.

The first task in Ancoats was
to grapple with the questions
of identity of a place that had
been irreversibly cut off from its
past and was facing an, as yet,
undefined and tenuous future.
The thread of the continuity of
culture had been severed. What
had made Ancoats Ancoats was
the sheer energy and density
of inhabitation and industry;
working and living, cheek by jowl
around the mills. An industrial
suburb that has lost its industry
for good means that something
new, in time, will have to make
Ancoats Ancoats.

While the area lacked the critical
mass of activity and population
it had very little of the energy it
needed to reestablish itself.

By taking readings, revealing the
presence of absence, the role of
the artist in this project becomes
more akin to an augur. In 2003
as the regeneration of Ancoats
kicked off with the cleaning and
demolition of sites, digging up
roads, compulsory purchasing
of buildings, some empty for
decades, and with the industrial
archaeologists and the ditchers
moving in, Ancoats revealed
its own trajectory. A number of
spaces, objects, phenomena
that had been walled up were
uncovered. Ancoats itself had
revealed how and where a
continuity of culture might be
achieved.

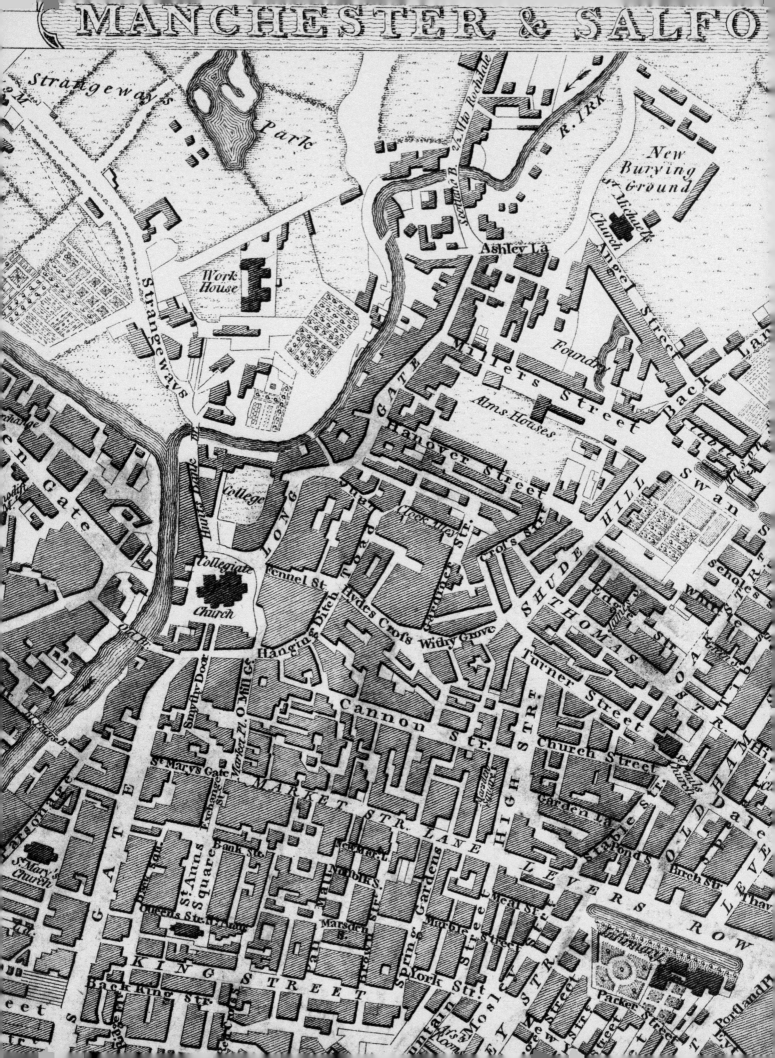

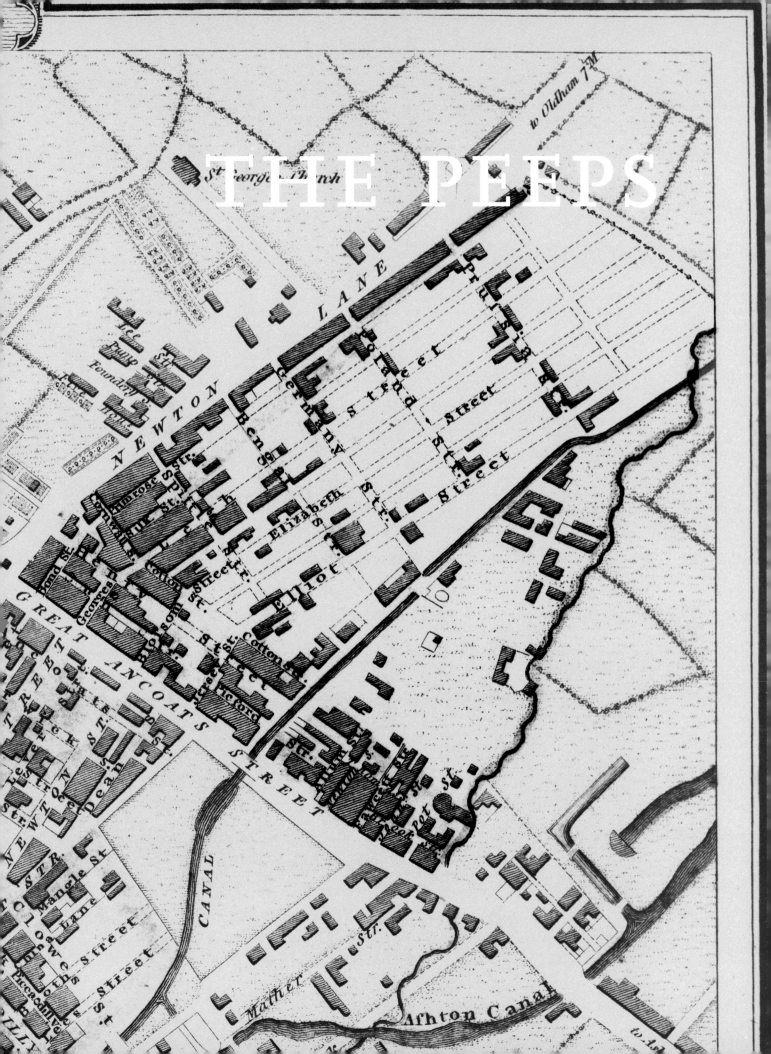

It all started with a phone call on a Thursday night from Stephen O'Malley the engineer. 'Dan, the contractors doing the road have uncovered a brick arched tunnel under Henry Street. We're filling it in on Monday so they can carry on with the road. I thought you'd like to see it. Its walled up at either end, we're going to break into it in the morning if you want to come and have a look at it.

When I arrived I was greeted by the sight of a man with his head in a hole in the pavement. Ten minutes later we were in the basement of the adjacent mill, breaking down a wall to get into the brick arched cavern with a stone flag floor and a plethora of stalactites dripping from the ceiling.

Another 10 minutes and I was negotiating with the contractor if there was not another stretch of road he could be getting on with for a few days. "What do you want to keep an empty space for?" I don't know yet, but there is something about it.

When we broke through into the walled up cavern under the road a dense and pungent smell was released and washed over us. It was a strange moment for all of us. I am sure for each of us it evoked a different experience and memory. For me it was a flashback to a visit to an ancient underground temple, the Necromanteion in Greece, said, by believers, to be the door to Hades. The latter had underground light-sensitive slugs the size of whales so I was not a little nervous as we clambered into the tunnel.

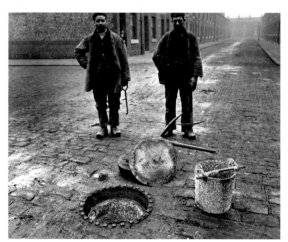

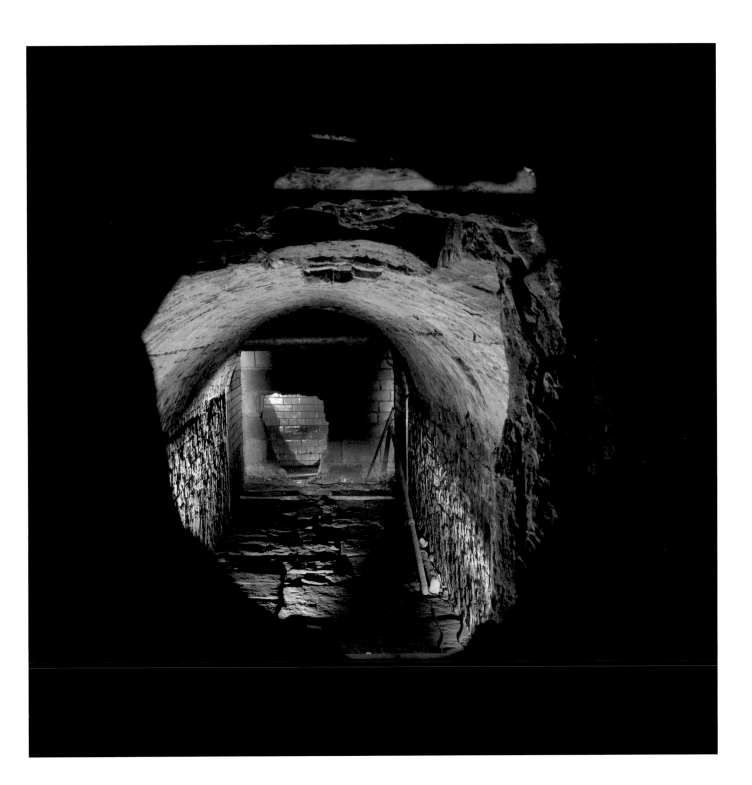

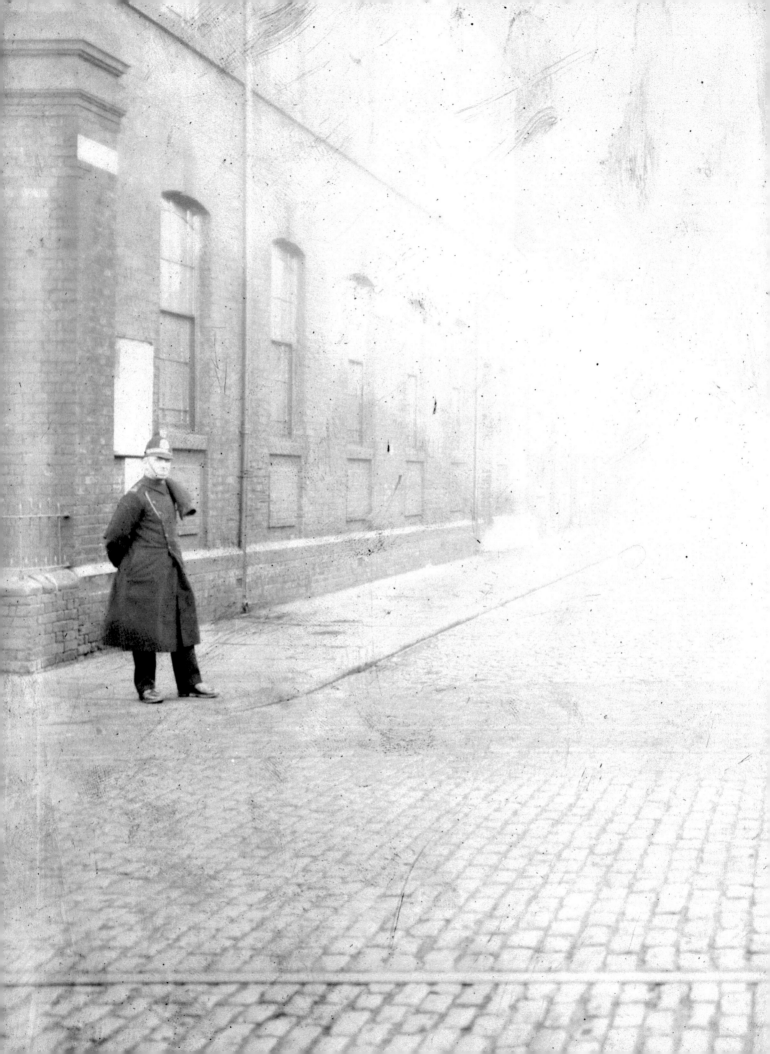

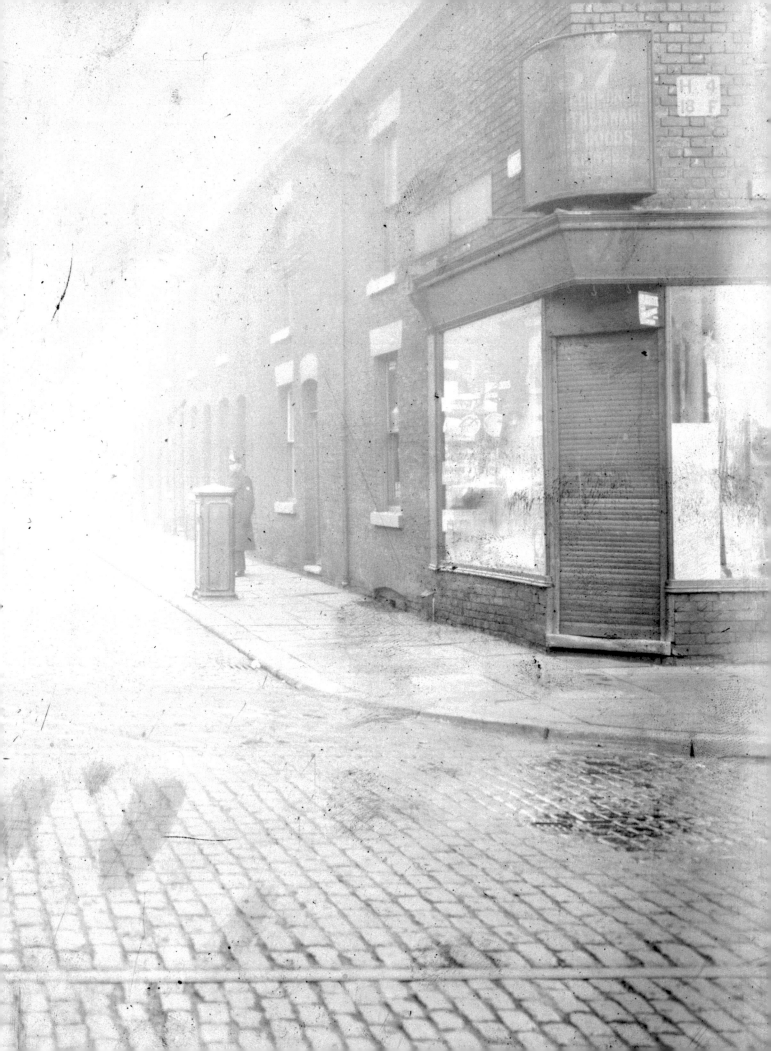

The Lunar Society

Matthew Boulton and James Watt formed a partnership in 1775 to make a much more efficient steam engine than was previously available. The time in which they lived and worked was a fertile one for science and technology. The Lunar Society grew up around Boulton and a small, exclusive group of the sharpest minds would meet regularly (around the time of the full moon, to aid a safe return home after dark) to discuss a range of subjects. The core of their small group included other engineers, scientists and thinkers, such as Josiah Wedgwood, Erasmus Darwin and Joseph Priestly.

It was Ancoats industrial archaeologist, Steve Little, in a new red jumpsuit. He withdrew his head from the hole, making sounds of excitement I thought only David Bellamy was capable of.

Later that day I took Serafino di Felice over to see the tunnel. An Ancoats veteran, he always had an interesting tale at the tip of his tongue. In true Serafino style he couldn't contain his excitement and he brought the street and the meaning of various elements to life.

"I know this tunnel" he said, "you see that nook there, there was a bell there, it was first in the bell tower up there on the corner of Royal Mill, then after a fire and to celebrate the visit of (Prince) Albert, it was re-sited here. Now let me tell you what that bell was about. Working in these mills wasn't like work today. It was a lock in and a lock out.

When that bell rang at the beginning of a shift the gates were closed and you stayed in for the day. These streets weren't safe for the mill products, access in and out of the mill was tightly controlled. If you weren't inside when the bell rang and the gates were shut, that's it, you lost a day's pay, no second chances. So when the mills expanded they swallowed up streets, but when that wasn't possible, they would tunnel under them and build walkways over them so they could move produce and workers between the sites without the risk of "losing" anything. The overhead walkways were for workers, the underground tunnels were for materials."

1733 Weaver John Kay's invention of the Flying Shuttle allowed for faster weaving and of wider fabrics, large looms could now be operated by just one person.

1765 Jame's Hargreave's invention of the Spinning Jenny multi spool spinning frame dramatically increased the number of threads a cotton machine could spin from 6 to 120.

1769 Richard Arkwright introduced water power to a spinning frame which increased the spindle count and reduced the number of people needed to spin yarn.

1779 Mill worker, Samuel Crompton, combined the best of the spinning jenny and the water frame to create a spinning mule that produced stronger and finer thread.

1781 Boulton and Watt developed the steam engine. It provided a more powerful and efficient source of power for the mills.

1812 Richard Robert's cast iron Power Loom introduces a significant improvement in the control and reliability of weaving machines.

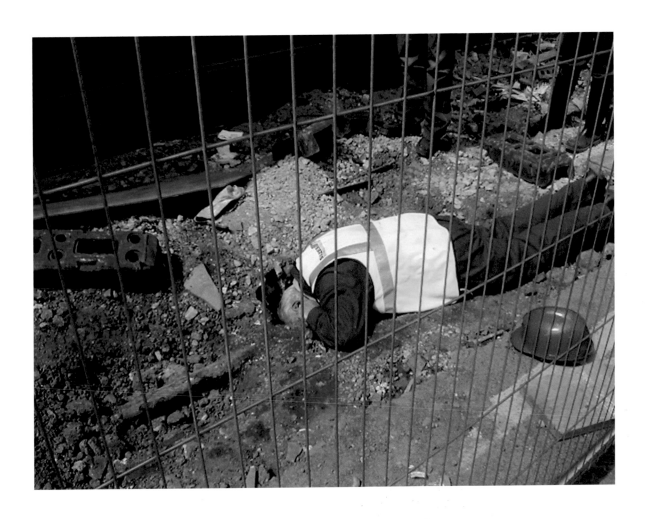

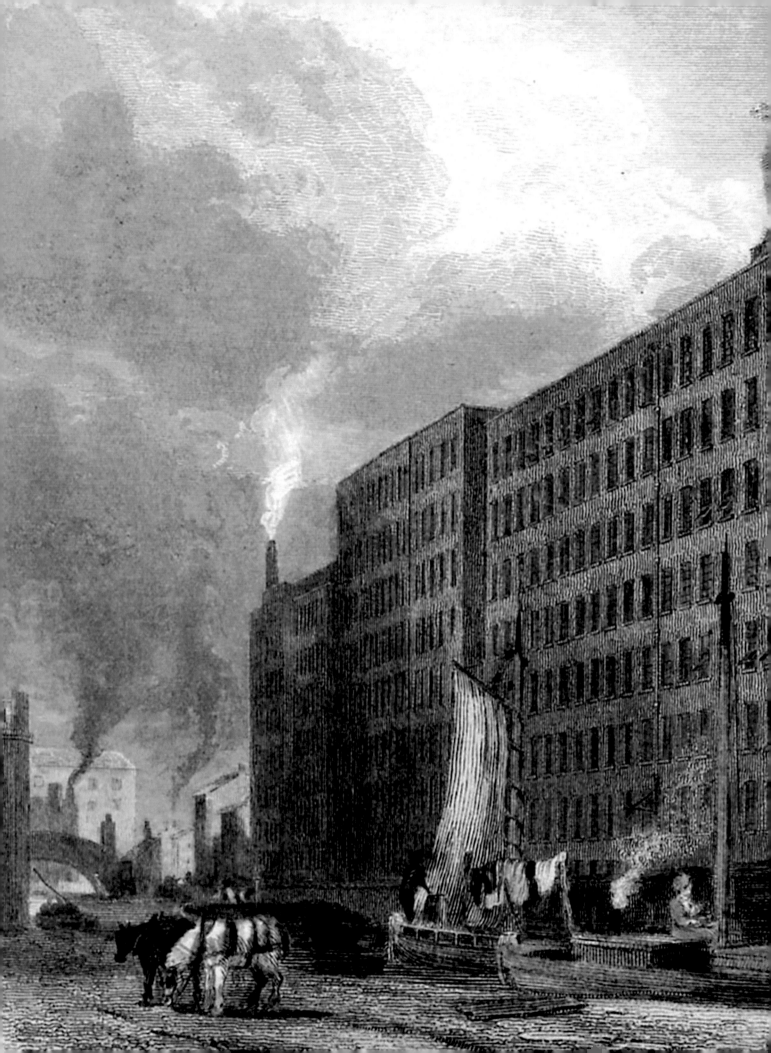

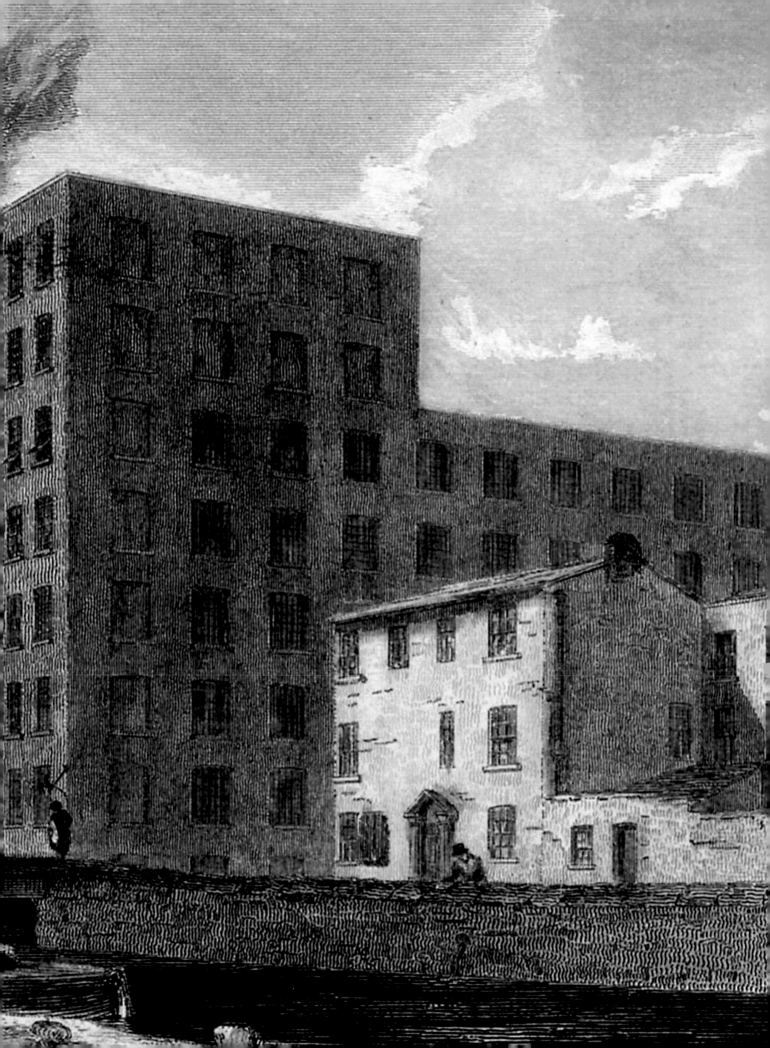

Edwin Chadwick in 1843 published a report on the sanitation of the working class population in Great Britain. Diseases spread rapidly, facilitated by overcrowded and unsanitary housing in the densely populated new industrial suburb. These settlements were cramped and primitive and there was no organised sanitation.

Victorian Britain believed that diseases were caused by a *miasma*, a noxious form of "bad air" considered to be filled with particles from decomposed matter (miasmata) that caused illnesses.

It was in this context that the burghers of Manchester built a public toilet sporting a fine ceramic urinal that drained directly into the canal.

Presumably before the privy was built this was already a popular spot for a pee in the shadow of the bridge to or from work or the pub. An enclosure was built so that peeing could continue, out of sight, out of mind. Little thought was given to connecting the privy to a sewer.

.....“Occasionally when an epidemic threatens [in Ancoats], the otherwise sleepy conscience of the sanitary police is a little stirred, raids are made into the working-men's districts, whole rows of cellars and cottages are closed, ... but this does not last long: the condemned cottages soon find occupants again, the owners are much better off by letting them, and the sanitary police won't come again so soon.”

Engels, 'The Condition of the English Working Classes' , 1844

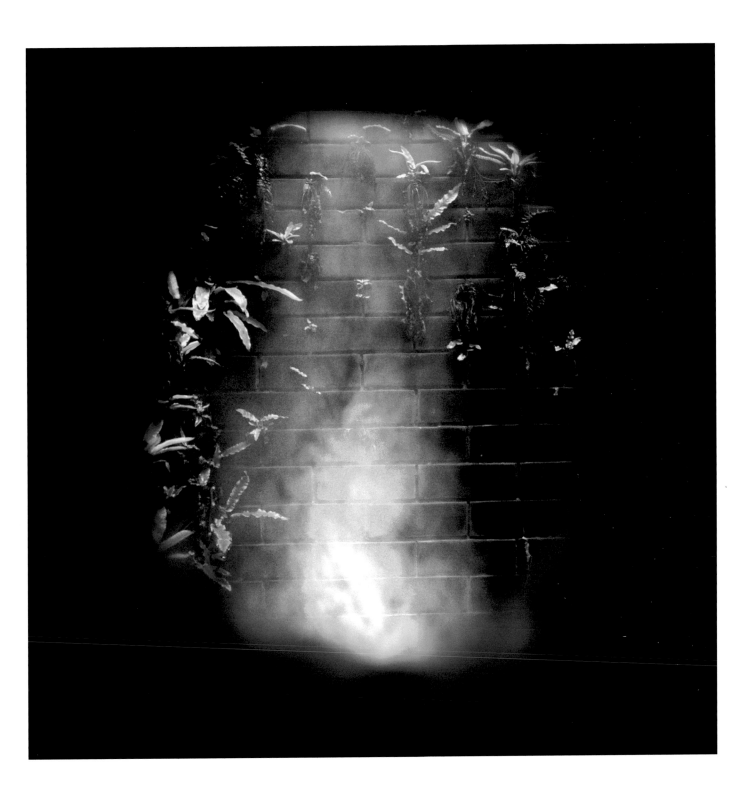

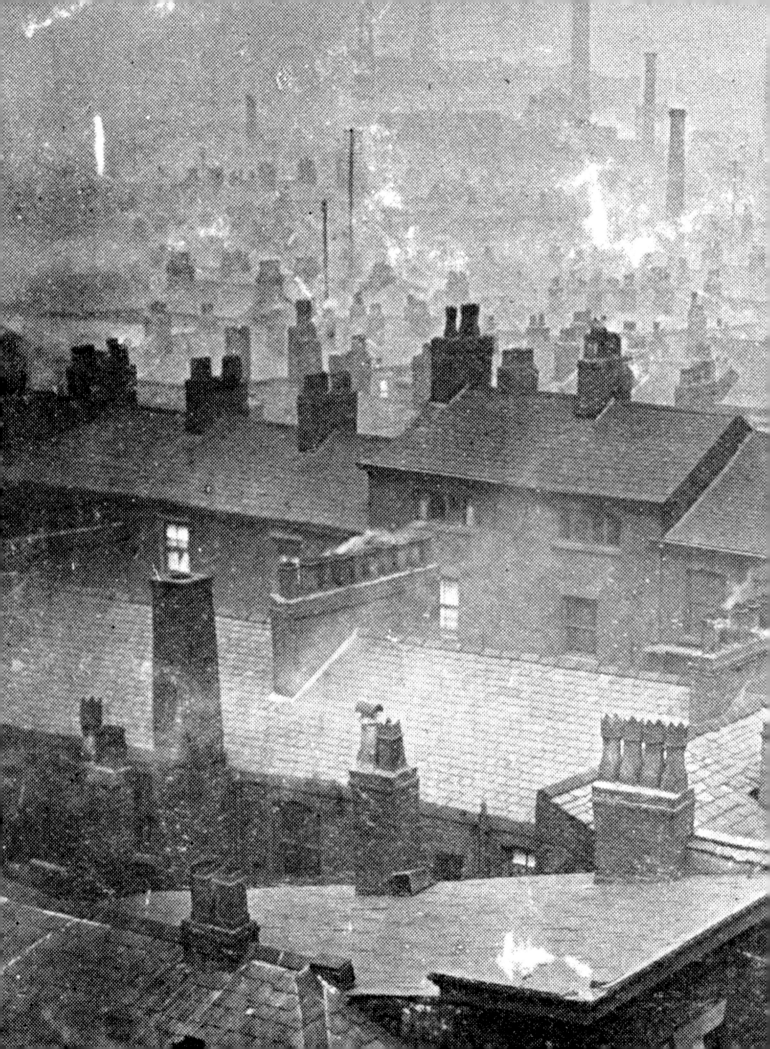

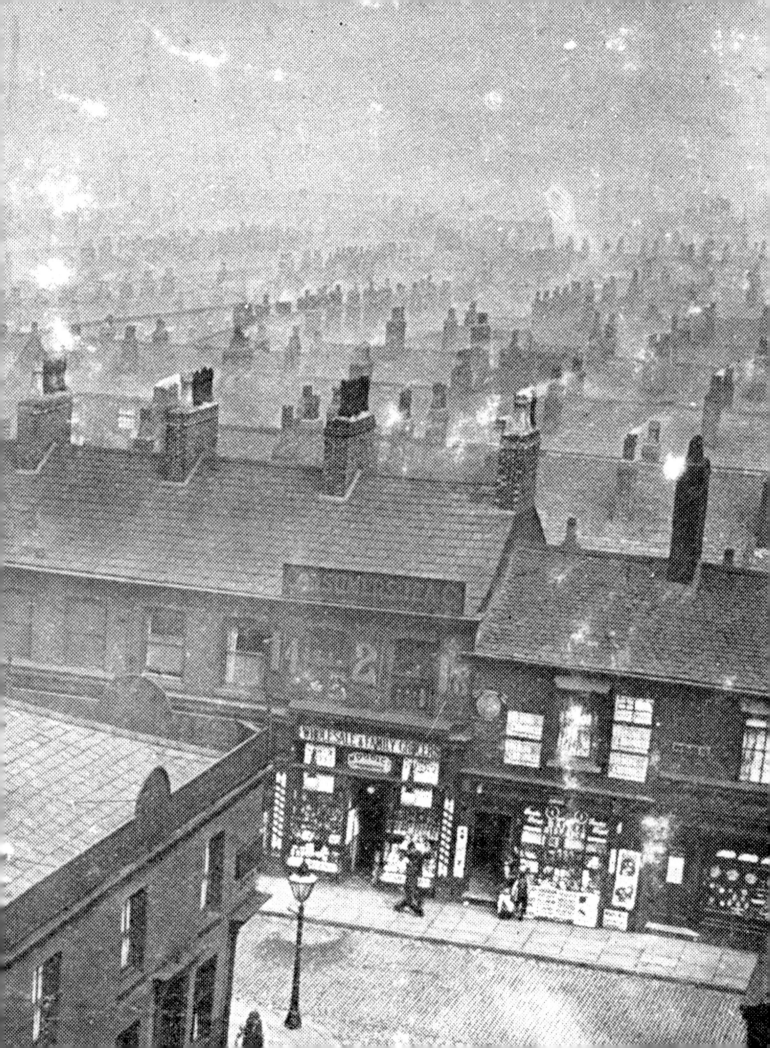

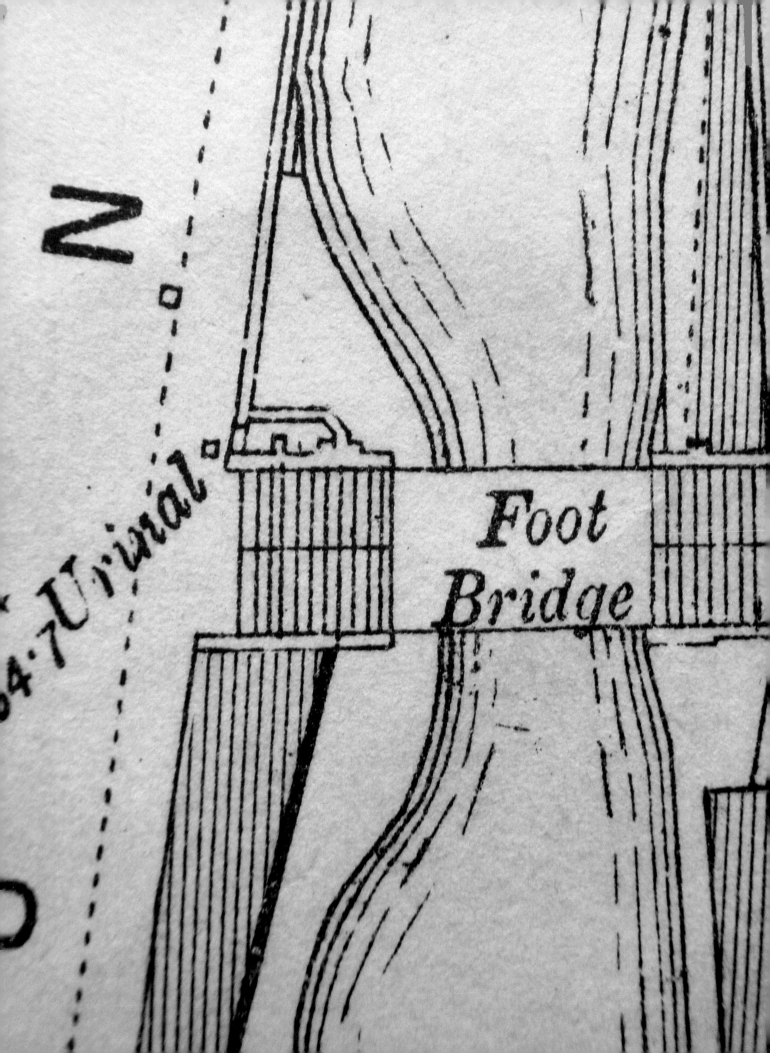

N

4.7 *Urinal*

Foot Bridge

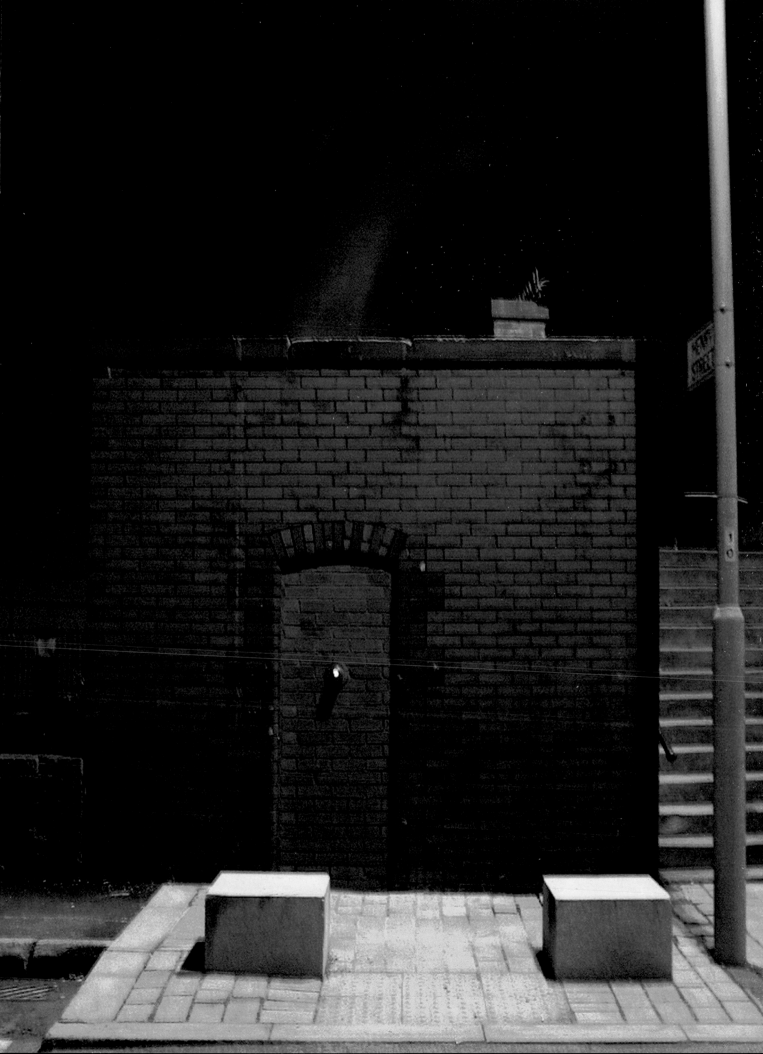

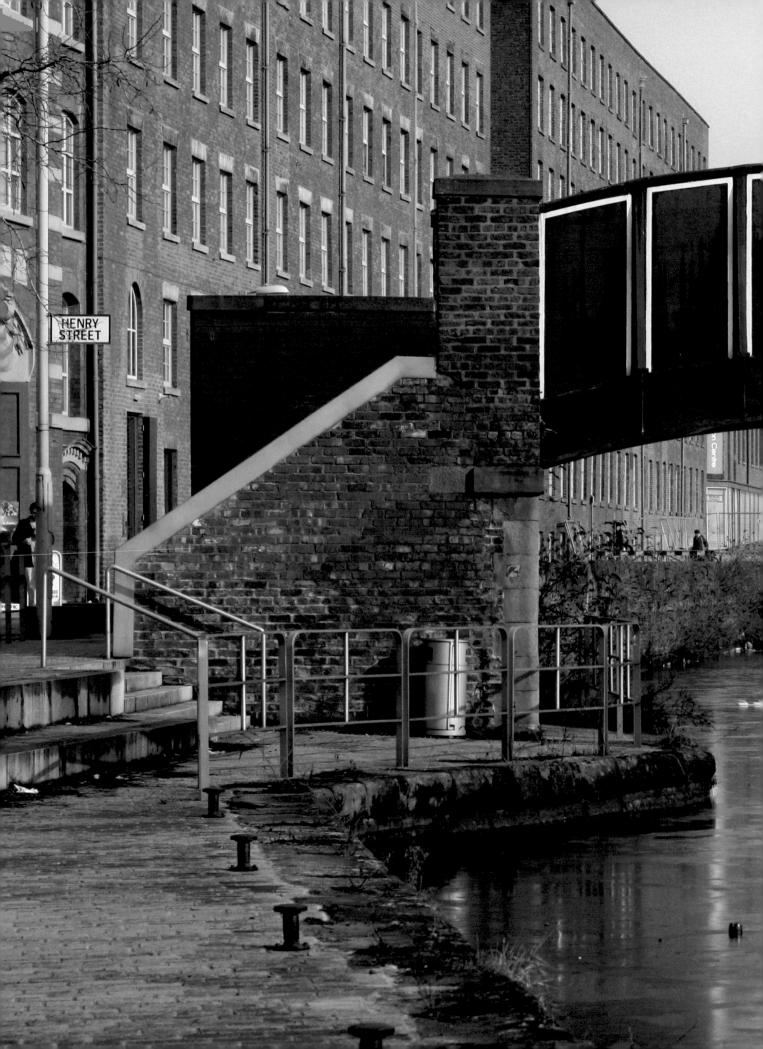

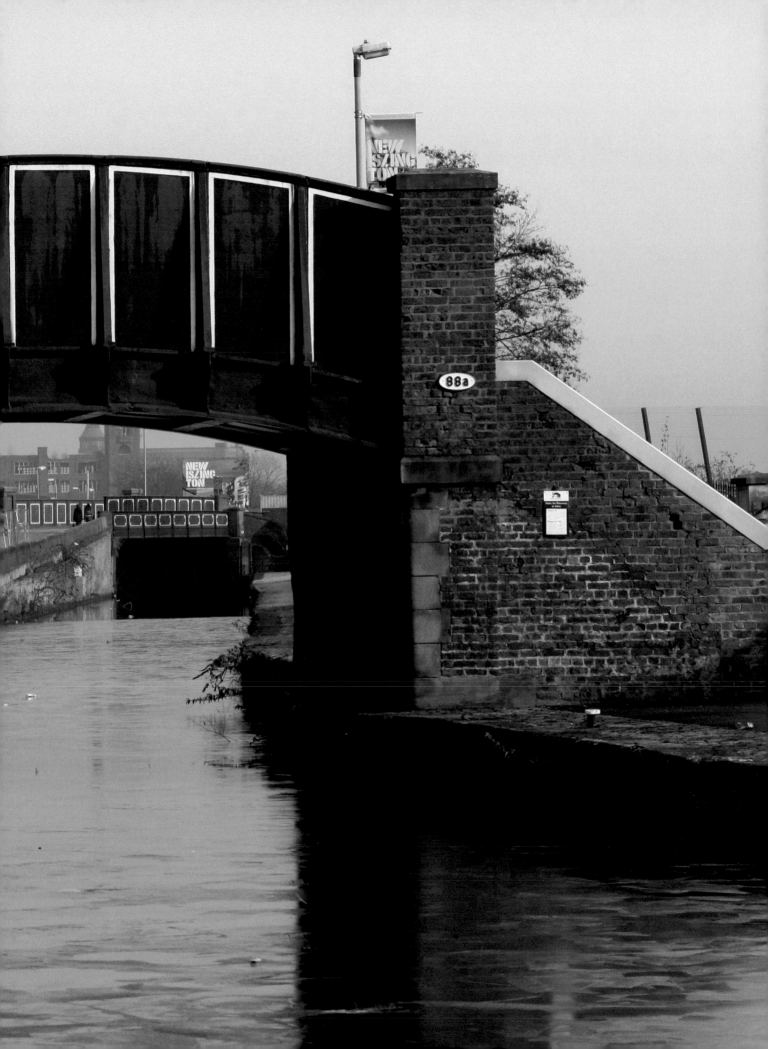

The Legend of Rozafat Castle

"Are you married? Do you all have wives?" "Yes, we are married," they replied, "Each of us has a wife. But tell us what to do to build the castle." "If you really want to finish the castle, you must swear never to tell your wives what I am going to tell you now. The wife who brings you your food tomorrow must be buried alive in the wall of the castle. Only then will the foundations stay put and last forever." Thus spoke the old man and departed. But alas, the eldest brother broke his promise and revealed to his wife at home everything that had happened and told her not to approach the place where the castle was being built. The second brother broke his promise, too, and told his wife everything. Only the youngest brother kept his word and said nothing to his wife at home.

The next morning, the brothers rose early and went off to work. Their axes resounded, rocks were crushed, the walls rose and their hearts beat faster and faster... At home the mother of the three brothers knew nothing of their plot. She said to the wife of the eldest brother, "The men need bread and water and their flask of wine, daughter in law." She replied, "I'm sorry, dear mother, but I really cannot go today. I am ill." The mother then asked the second wife, who answered, "My word, dear mother, I cannot go either, for I must visit my parents today." The mother then turned to the youngest wife, saying, "My dear daughter in law, the men need bread and water and their flask of wine." She got up and said, "I would willingly go, mother, but I have my young son here and am afraid he will need weaning and will cry." "You go ahead," said the other two daughters in law, "we shall look after the boy. He won't cry."

So the youngest and best wife stood up, fetched the bread and water and the flask of wine, kissed her son good bye on both cheeks and set off. She climbed up Mount Valdanuz and approached the place where the three workers were busy. "I wish you success in your work, gentlemen!" But what was wrong? The axes stopped resounding, their hearts beat faster and faster, and their faces turned pale. When the youngest brother saw his wife coming, he hurled his axe into the valley and cursed the rocks and walls. "What is the matter, my lord," his wife asked, "why are you cursing the rocks and walls?" Her older brothers in law smiled grimly and the oldest one declared, "You were born under an unlucky star, sister in law, for we have sworn to bury you alive in the wall of the castle." "Then may it be so, brothers in law," replied the young woman. "I have but one request to make. When you wall me in, leave a hole for my right eye, for my right hand, for my right foot and for my right breast. I have a small son. When he starts to cry, I will cheer him up with my right eye, I will comfort him with my right hand, I will rock him with my right foot and I will wean him with my right breast. Let my breast turn to stone and may the castle flourish. May my son become a great hero, the ruler of the world!"

They then seized the poor young woman and walled her into the foundations of the castle. This time the walls did not collapse, but stayed put to rise higher and higher. Even today, at the foot of the castle, the stones are still damp and mildewed from the tears of the mother weeping for her son.

Dr Robert Elsie

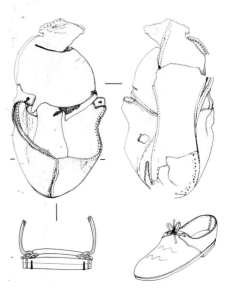

Drawing by archaeologists of shoe found immured in Royal Mills

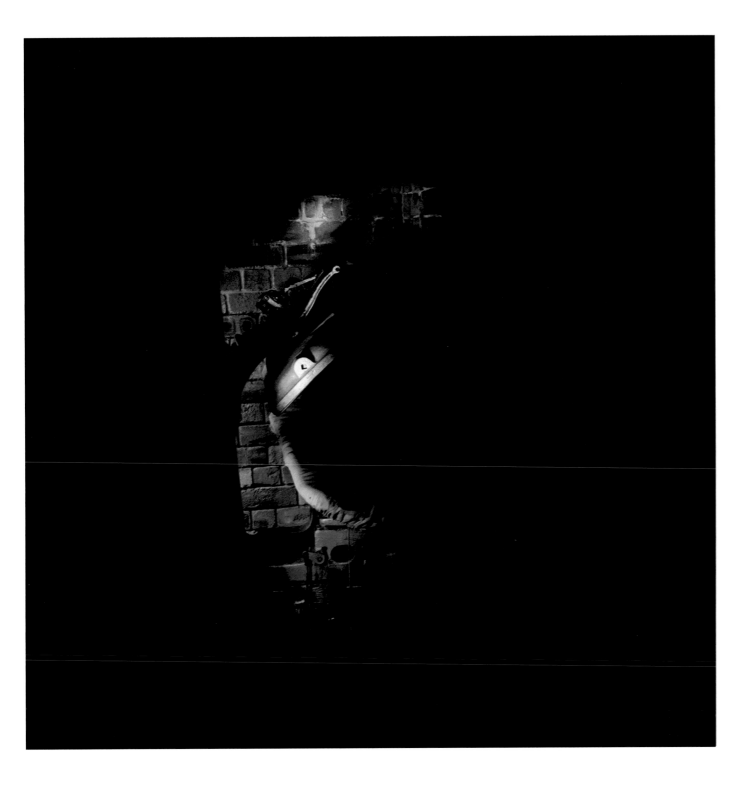

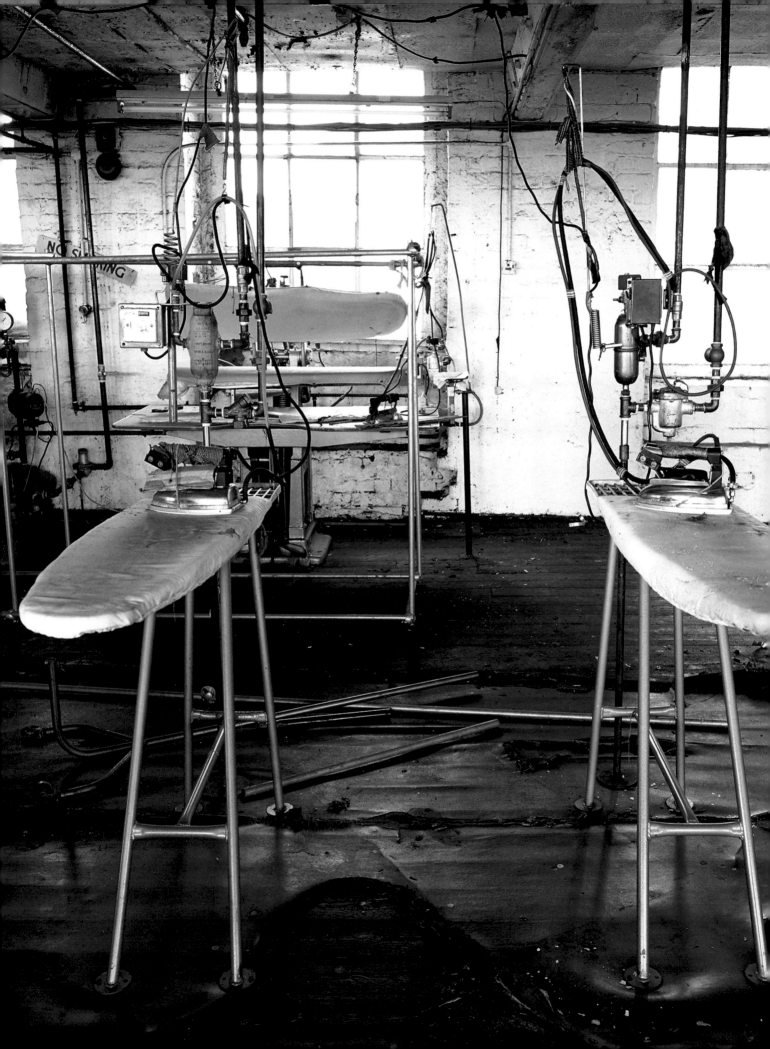

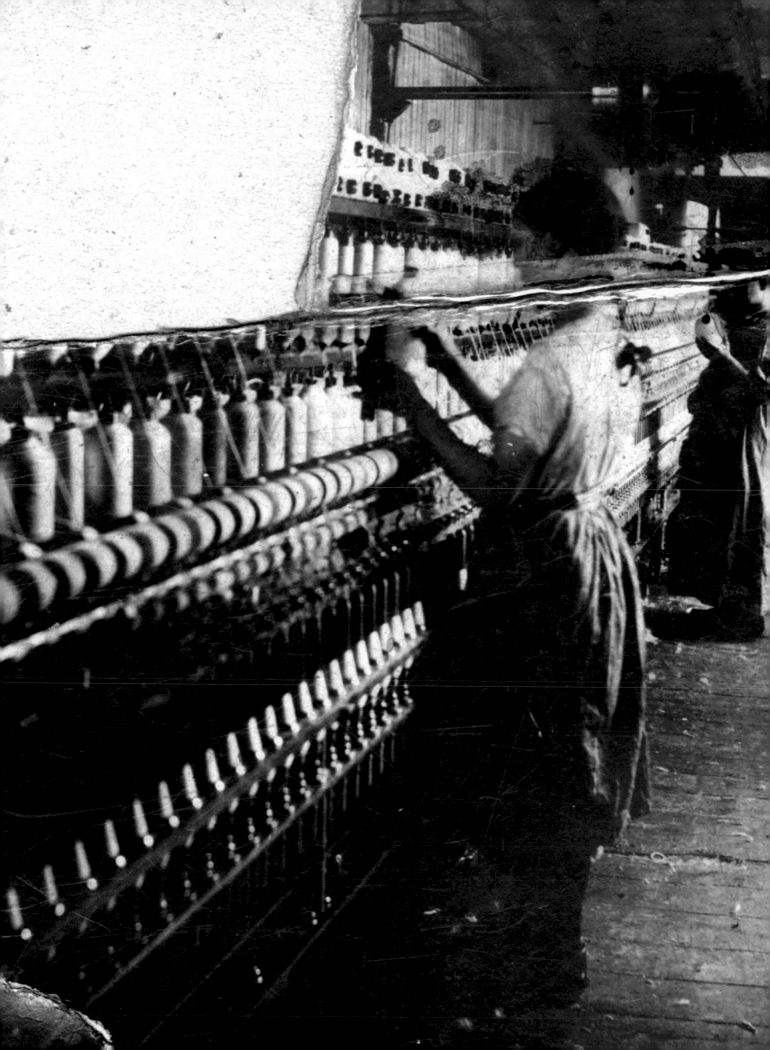

The industrial archaeologist set out his grid on a portion of the top floor of Murray's Mills and went off for lunch. When he came back a bit of the ceiling had fallen in over the grid and on the top of the pile, shining, was an old penny from the year the building was constructed. Chance favoured this young archaeologist. I often wonder how he will respond? I wonder if he will reinstate the coin entrusted to him when Murray's Mill is developed?

"The fine spinning mills at Manchester so grossly disparaged by the partisans of the ten-hours Bill, are the triumph of art and the glory of England. In the beauty, delicacy and ingenuity of the machines, they have no parallel among the works of man."

Andrew Ure, *The Philosophy of Manufactures*, 1835.

Within sealed confinement, change continues – the buildings are incapable of remaining static. Nothing we do to them will make them immune to change. And with each change another layer of history is added; another surface created; another story told.

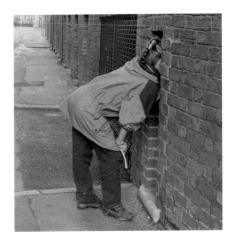

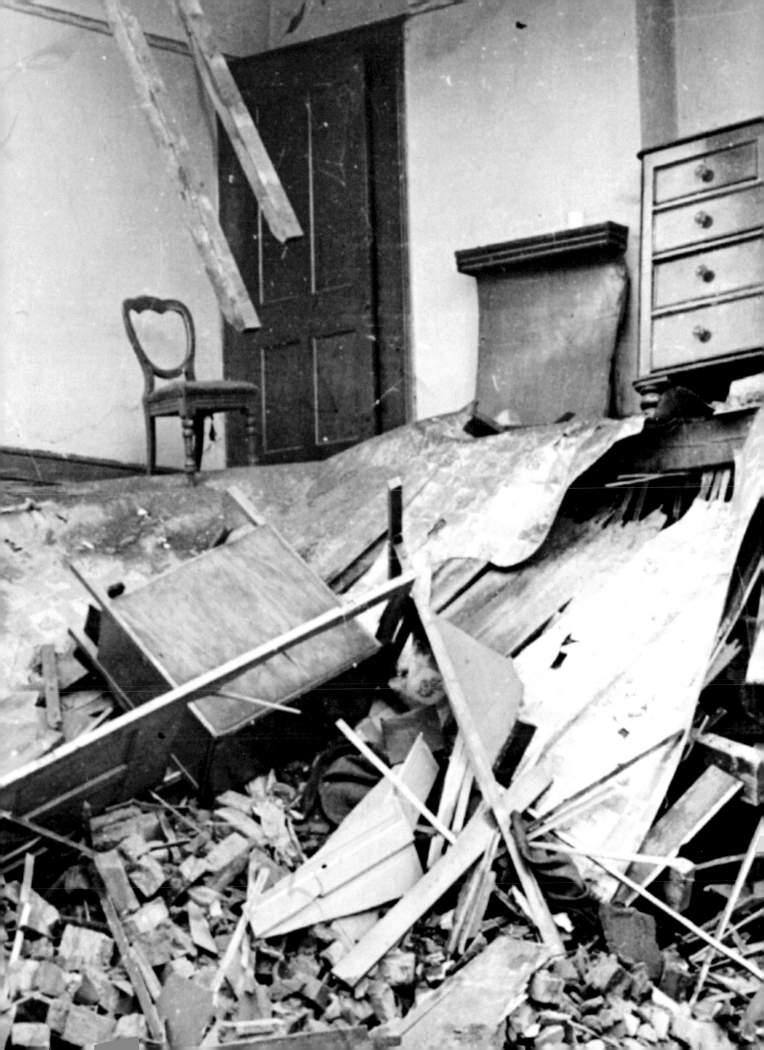

The Chartists

In 1838 the People's Charter was published which campaigned for suffrage reform. Specifically it stipulated six main aims:

1 a vote for every man over 21 years of sound mind

2 the secret ballot

3 no property qualification for MPS, meaning that not only the rich could be elected

4 payment of MPS, again enabling men of modest income to hold the position

5 equal constituencies, ensuring equal representation

6 annual parliaments to discourage bribery and intimidation

Although the Chartists did not see immediate success, by 1918 the first 5 of these demands had been established.

Their legacy lies in galvanising support for later suffrage movements, and in forming possibly the world's first mass working class labour movement.

Suffrage

Suffrage had changed little since being set by King Henry VI in 1432. Generally only adult men who owned property worth more than 40 shillings could vote. Also boundaries were highly unequal; Old Sarum in Wiltshire was represented by 2 MPS but had only one voter, while the one million people living in Manchester, Salford, Bolton, Blackburn, Rochdale, Ashton-under-Lyne and Oldham were also represented by 2 MPS.

In 1831 William Carpenter wrote in "The People's Book; comprising their chartered rights and practical wrongs" that; "it will appear that a very great majority of the house of commons (which consists of 658 members) is returned by the influence of less than two hundred peers and commoners!"

70 NUMERICAL LIST OF PARTS

No.	Plate	
453c	1602	Oscillating Shuttle Shaft Collar Set Screw for 91030
SS463d	1465	Clamp Stop Motion Clamp Screw for 95190 and 98625
SS531c	1769	Oscillating Rock Shaft Hinge Pin Screw Bearing
SS537e	1769	Oscillating Rock Shaft Steel Plate Binding Screw for 98638 and 98639 ...
SS574d	1602	Shuttle Cylinder Latch Spring Screw for 98624
597c	1602	Driving Attachment Shaft Pulley Clamping Screw for 84275
693d	1602	Driving Attachment Lever Hinge Screw for 91722 and 95152
694d	1602	Foot Lifter Arm Lever Hinge Screw for 91456 and 94843
704c	1602	Feed Dog Screw for 45K57 Machine ...
727c	1060	Driving Attachment Lever Adjusting Screw for 95152
1128e	1602	Feed Regulator Hinge Screw for 45K57 Machine
1177c	1060	Feed Rock Shaft Crank Clamping Screw for 91564
1186d	1751	Presser Bar Lifting Bracket Clamping Screw for 94827 and 94861 ...
1186f	1751	Lifting Presser Plunger Bracket Clamping Screw for 94821 and 94857 ...
1259c	1060	Feed Rock Shaft Carrier Slide Set Screw for 91165
1302e	1060	Shuttle Race Ring Screw for 45K57, 45K75 and 45K76 Machines
1508e	1603	Driving Attachment Lever Centre Plug Adjusting Screw Nut for 91722 ...
1513j	1603	Oscillating Rock Shaft Hinge Pin Nut ...
1513j	1603	Oscillating Rock Shaft Hinge Pin Screw Bearing Nut
1518e	1603	Feed Connecting Link Hinge Screw Nut for 45K57 Machine
1518e	1603	Feed Forked Connection Hinge Screw Nut for 45K57 Machine
1518e	1603	Needle Bar Connection Link Hinge Screw Nut
1518e	1603	Oscillating Shuttle Shaft Crank Roller and Screw Stud Nut for 98634 and 98635 ...
1518e	1603	Presser Bar Lifter Hinge Screw Nut ...
1519e	1603	Thread Take-up Lever Roller and Screw Stud Nut for 91258 and 94866 ...

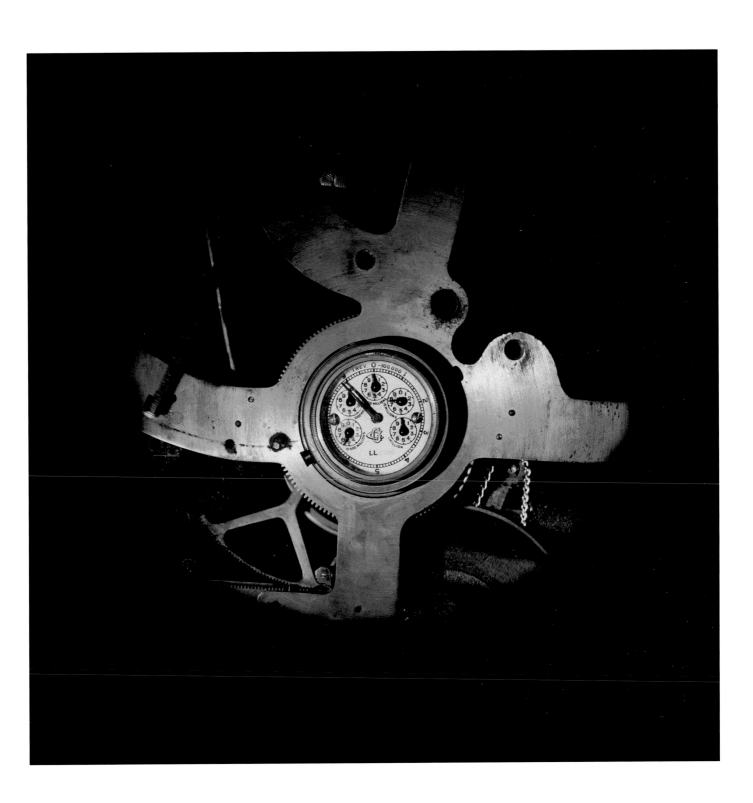

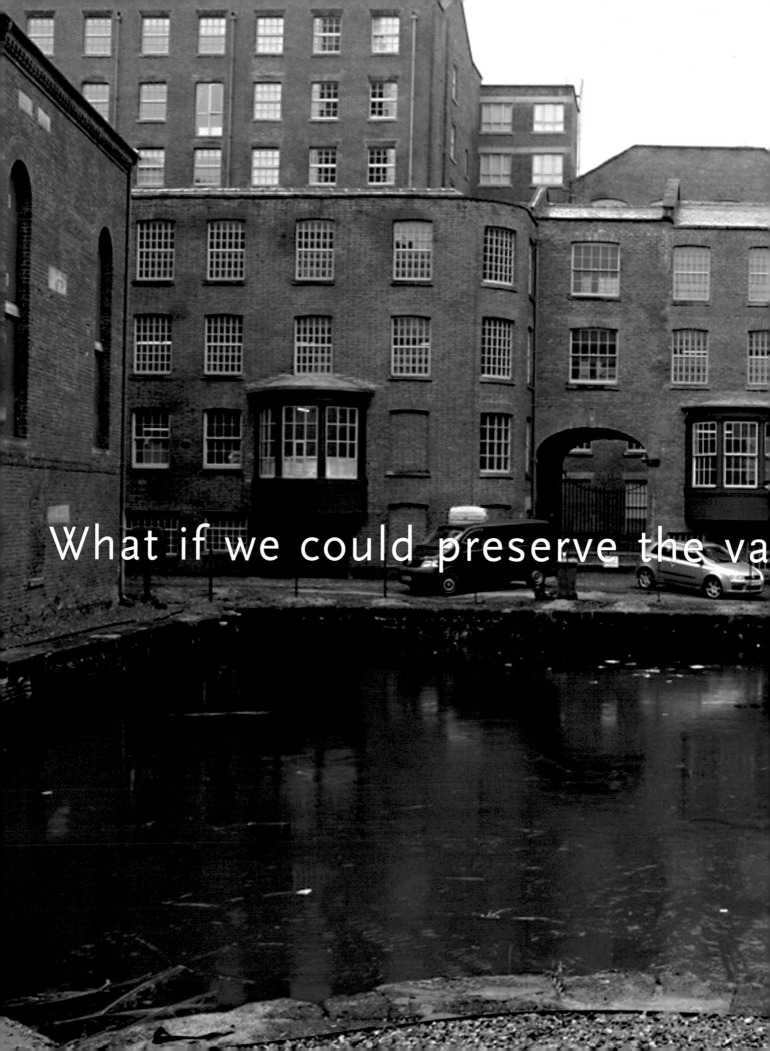

What if we could preserve the va

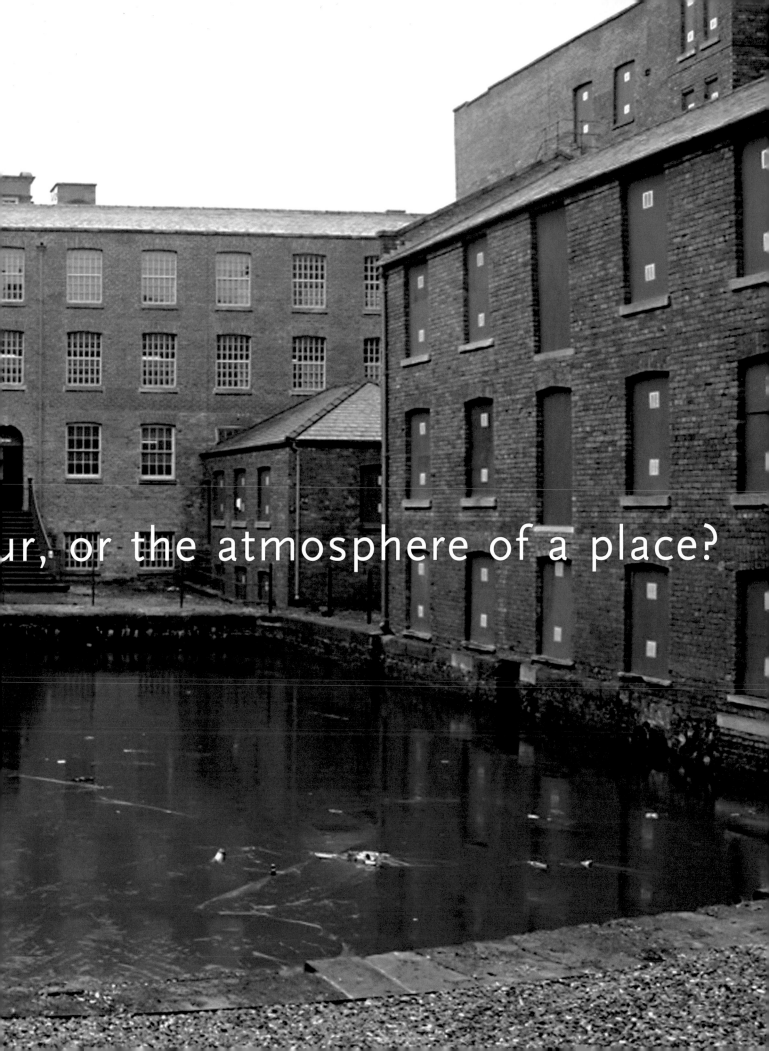

ur, or the atmosphere of a place?

In Manchester Engels met Mary Burns and her sister Lizzy, the daughters of a cotton mill dyer. It is likely that Mary had worked in a mill from a young age, although the 1841 census records her as a domestic servant. The sisters lived off Deansgate, described in detail by Engels in his first book 'The Condition of the English Working Classes' in 1844, as "even in the finest weather a dark, unattractive hole...."

Friedrich Engels came to Manchester in 1842 aged 22. The son of a German textile manufacturer, he was sent to work in the family business by his father who hoped he would reconsider the radical philosophical ideas learned while doing military service in Berlin.

Mary and Lizzy are thought to have been Engels' guides to Manchester and its working classes, ensuring his safe movement, which for a wealthy foreigner, could not have been taken for granted at that time, and introducing him to members of the Chartist movement. Engels had a strong perspective from which to critique the working conditions of the time. As a partner of Ermen and Engels he saw intimately what day to day life was for his employees.

Mary and Engels remained in a relationship until her sudden and early death in 1862, but for ideological reasons never married. Marx's daughter Eleanor described her as "pretty, witty and altogether charming" and mentions that Marx and his wife spoke very affectionately of her.

For many years, Mary and Lizzy kept a boarding house. Engels stayed there when possible but felt obliged all the time to rent his own rooms for the sake of appearances. After her death, he had a relationship with Mary's sister Lizzy.

Engels continued his own brand of double life for many years, outwardly a respectable mill owner, carefully protecting his reputation among Victorian society, while at the same time working with and financially supporting Marx from the profits of his company.

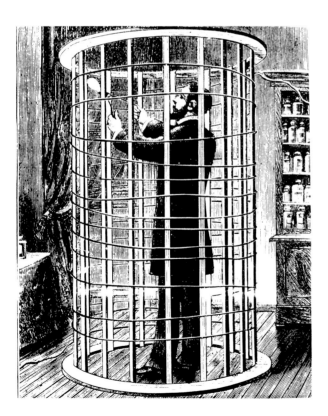

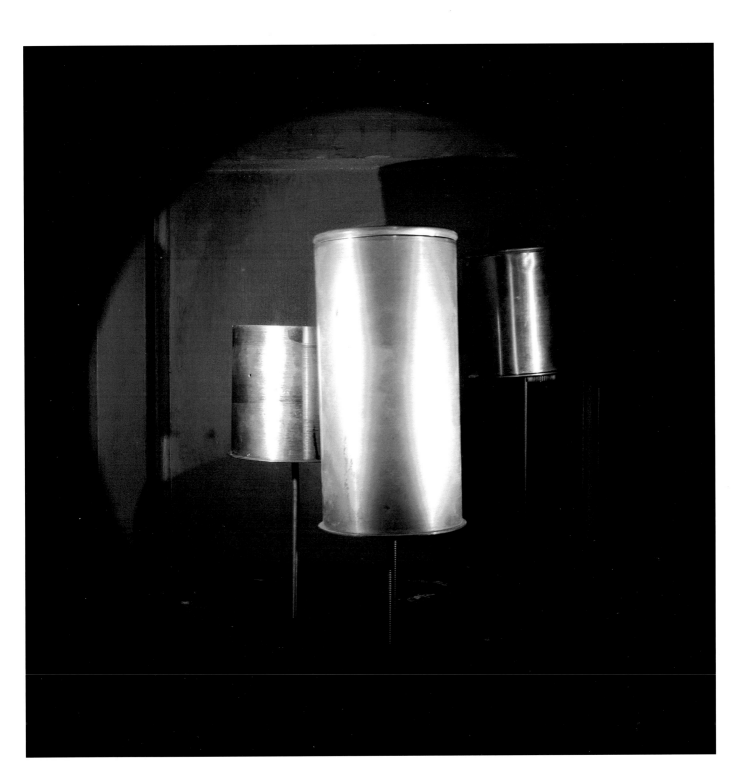

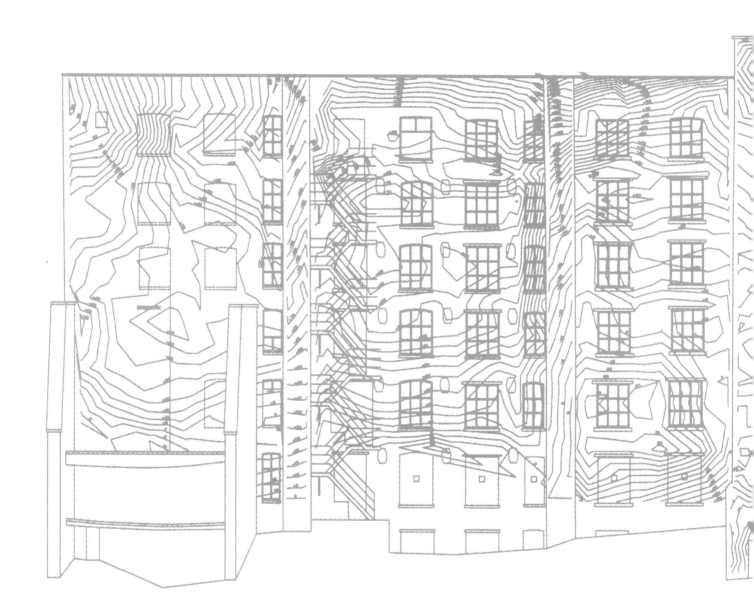

Mapping of surface contours of Murrays Mills by BDP.

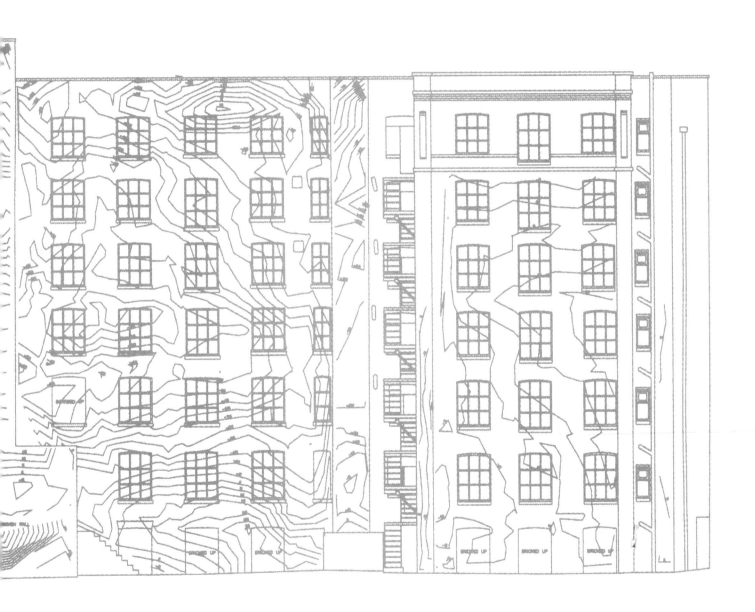

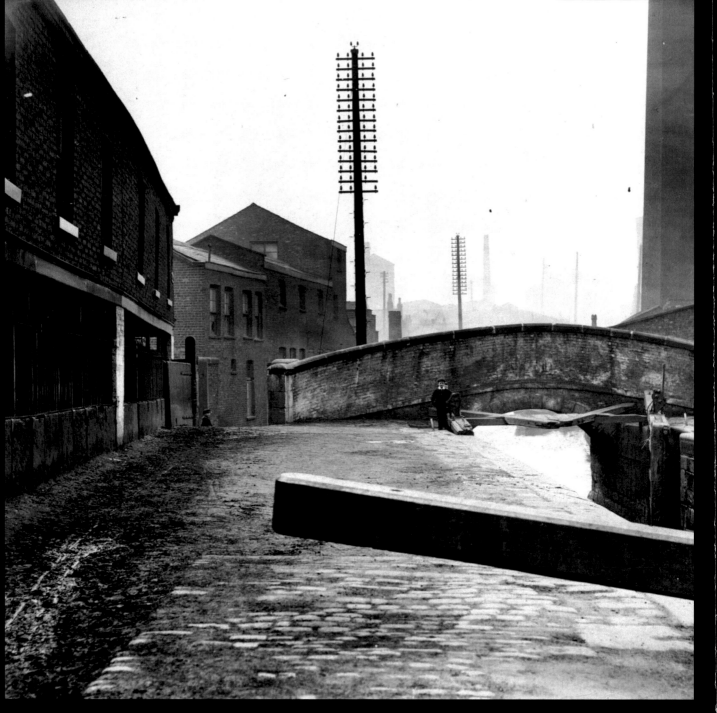

The huge strides in communications technology made at the turn of the millennium have revolutionized the way we interact with those outside of speaking distance with us. Telephones, then mobile phones, pagers, email and the ability to have a video conversation in real time with someone in another country, hemisphere, or even in space orbiting Earth make it even harder to imagine what life was like before this astonishing technology.

Before email, before the cell phone, before the fixed telephone there was paper and ink. A letter could travel only as fast as it was carried; before airplanes by trains, before trains by foot, horse or pigeon. Depending on the destination many months might pass before a letter arrived, many more months for a reply. People who went away were isolated in a way that is now almost always possible to avoid.

From the late 1840s the telegraph spread throughout the country and those who could afford it were able to send and receive messages which took only a few minutes to arrive at another telegraph office in the country, not much longer to reach another continent.

This too was a revolution.

It oiled the wheels of the industrial revolution, and the telegraph poles along Redhill Street in the 19th century bear testament to how Ancoats functioned as the centre of the world's cotton industry. Suppliers and customers were spread around the world. That they were immediately and easily contactable was a massive advantage to the Cotton Kings of Ancoats.

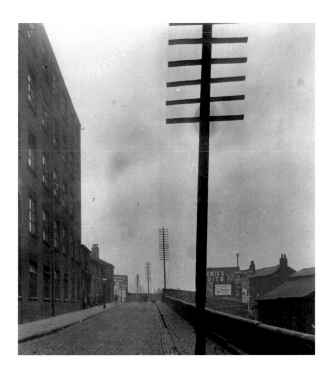

The man in a black polo neck shirt, the one with a large scale plan, and brandishing a thicker pen than everyone else is looking to achieve a god's eye view.

Contemporary masterplanning is rooted in attaining a distance from a place and a degree of abstraction (usually through a computer or drawing). It wasn't always like this.

In the British Museum collection is the divining liver of Babylon. A fist sized stone with a grid marked out with a hole for a stick in each and a number. The stone was a reference tool for reading sacrificed livers to divine the auspices for founding or extending a town. For founding an Etruscan town an augur might follow particular animals to see where they gave birth. After sacrificing the animal the liver was then read. In contemporary western society the rituals for founding a town have been replaced by the professional and legal processes of masterplanning. They could not be more different. Ancient rituals from augury to immuration reflect a process that entailed a physical interaction and dialogue with a place; the balancing of rational considerations with intuitive and derived ones. Now decisions are often devoid of first hand, detailed knowledge of the place to be transformed.

"If we briefly formulate the result of our wanderings, we must admit that 350,000 working-people of Manchester and its environs live, almost all of them, in wretched, damp, filthy cottages, that the streets which surround them are usually in the most miserable and filthy condition, laid out without the slightest reference to ventilation, with reference solely to the profit secured by the contractor. In a word, we must confess that in the working-men's dwellings of Manchester, no cleanliness, no convenience, and consequently no comfortable family life is possible; that in such dwellings only a physically degenerate race, robbed of all humanity, degraded, reduced morally and physically to bestiality, could feel comfortable and at home. And I am not alone in making this assertion."

Engels, 'The Condition of the English Working Classes', 1844
Translated Florence Kelley Wischnewetzky, 1885
First published London 1891

"Who does not know that this city was founded only after taking the auspices, that everything in war and in peace, at home and abroad, was done only after taking the auspices?".
Livy VI.41 Roman historian

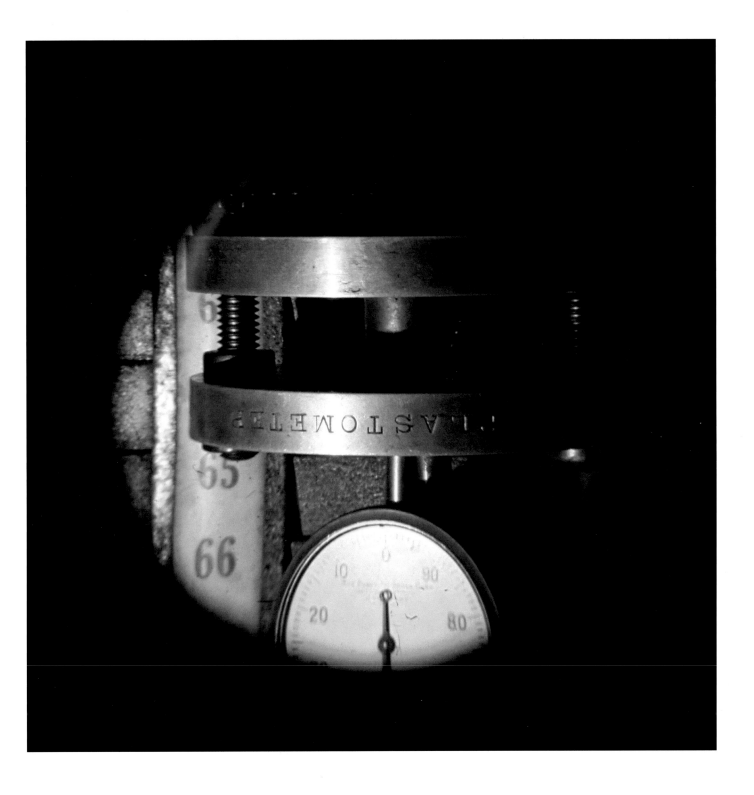

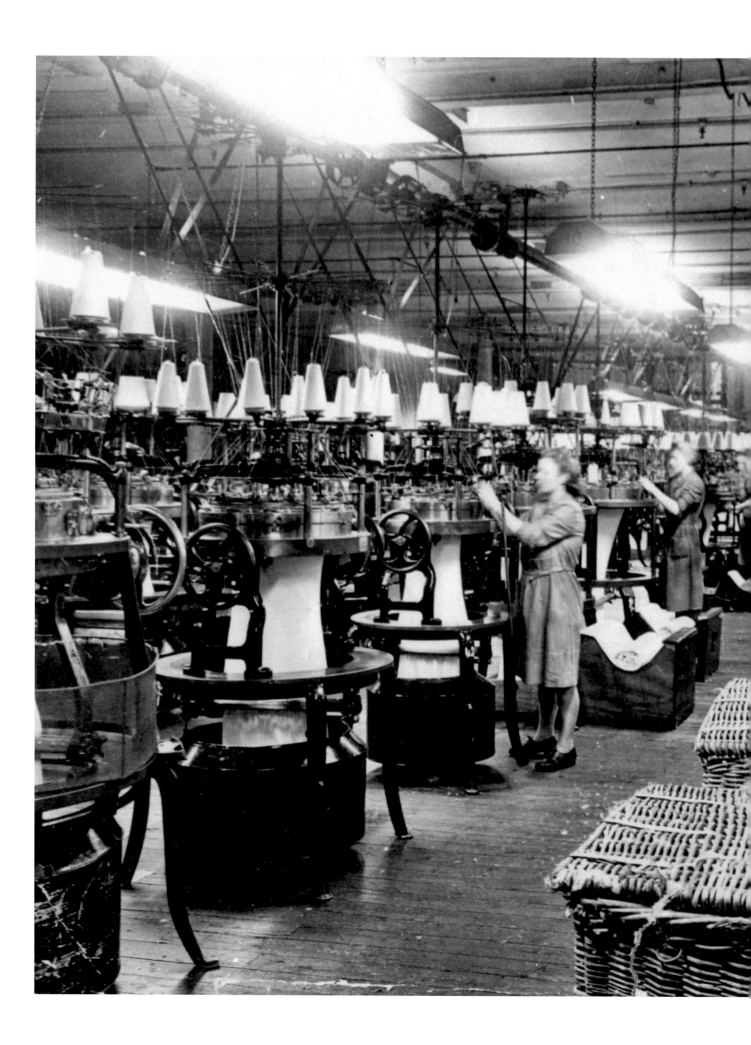

"Sir,

This is my last report from the Men's Home. At the end of the month
we close our doors, and maintain only a nucleus until the building is
disposed of. Before this happens, I should like to say something of the
course we have run during the 23 years I have been at the home.

...

It was a time of slump. Three hundred men were sleeping in the
Home each, and every night. Of these a hundred were occupying
free beds. The workyard was finding daily work for 75 men. Nearly
100 were paying sixpence for their nightly beds and being given a
simple free breakfast along with a bed. Each dinner hour sixty or
seventy received free soup. Each Friday night and Sunday afternoon,
we had 300 men in the Lesser Hall, and each time gave them tea
and buns. They ate and drank while we sang and prayed. Sometimes
they heckled. The Stephenson Square orators used to come to garner
ammunition for their subsequent address from their soap boxes.
As they came to my meeting, now and then I went to theirs, and
meekly heard myself called all manner of names for half an hour.
It ensured one thing – I should have a good crowd the next Sunday.

...

But 'the mill cannot grind with the water that is passed'. The second
world war and the Welfare State have created new conditions in which
the work we have been doing on a purely social side has become
outmoded. It has never been made impossible. Whatever is to be done
for men now will have to be done along different lines. Not that the
problems have disappeared. The grinding poverty, the hopelessness
of prolonged unemployment have gone, but so, at present, has some
of the independence that marked the men even in the worst of the
slump. For, let me say it, if I may, there was something about the old
villains we used to have that one could love more quickly and easily
than one can the state helped misfits of today. They didn't cling so
much. You always felt that, if you helped them to stand on their own
feet, at least they had feet to stand on.

...

So I trust will God sprout the tardy seed sowed at our Men's Home,
for "in His will is our peace".

Gerald Carpenter's final report (Extract)
The Hood Street Men's Methodist Home dated June 1st 1951

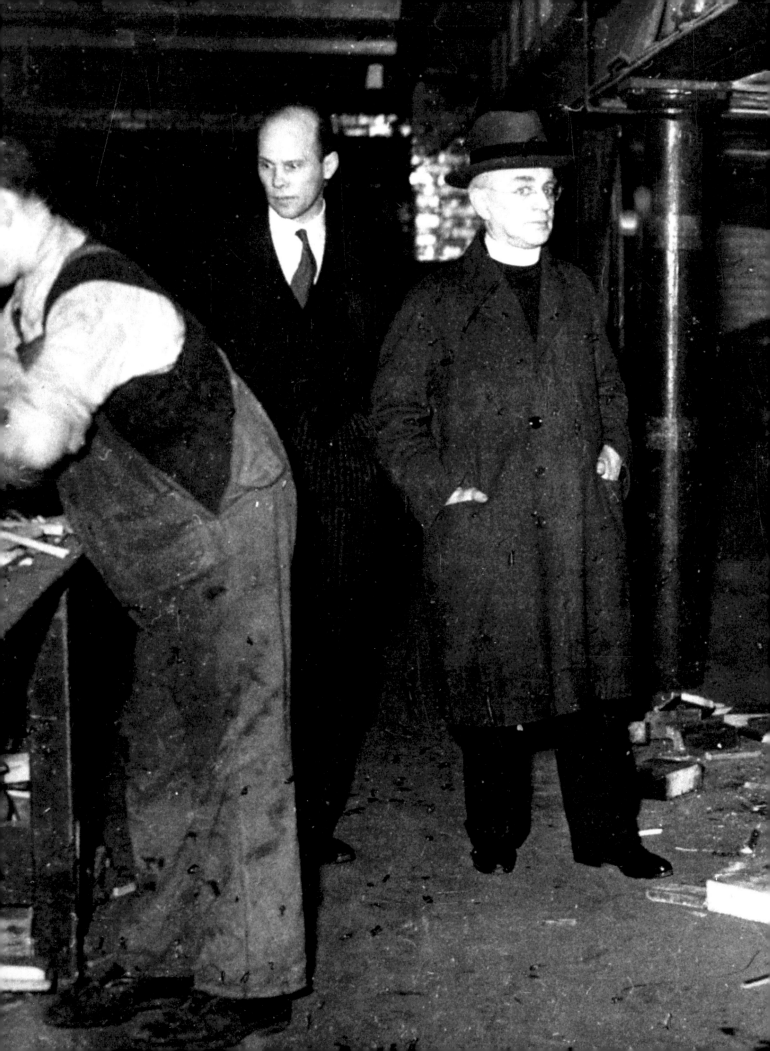

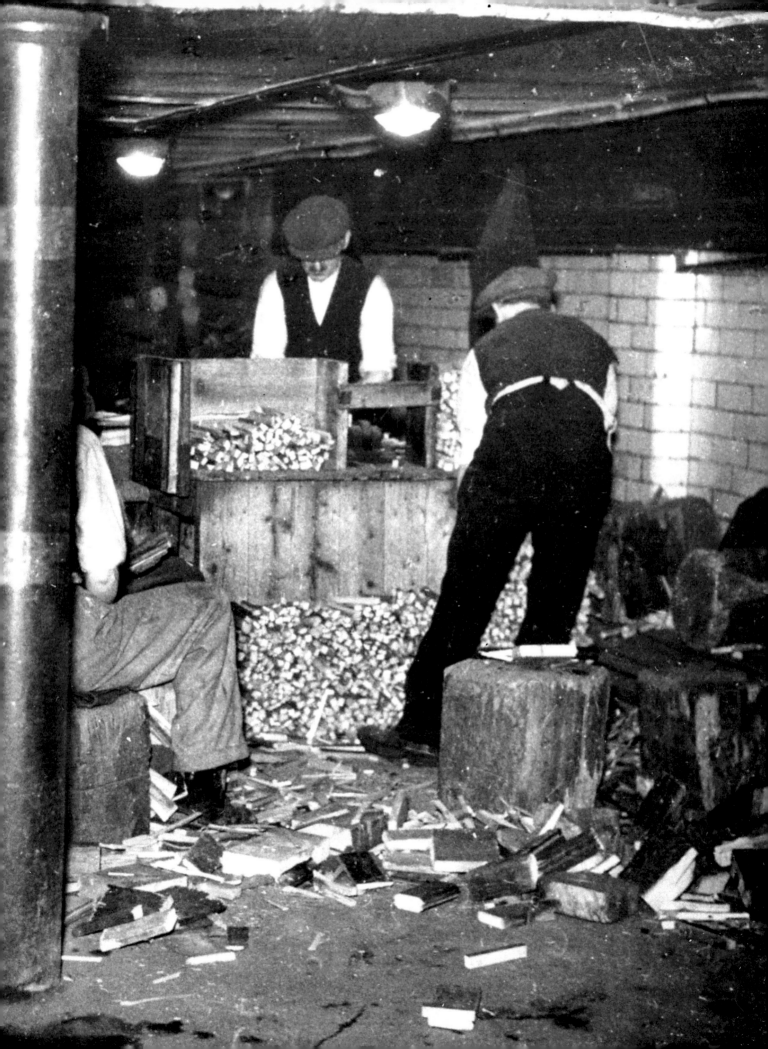

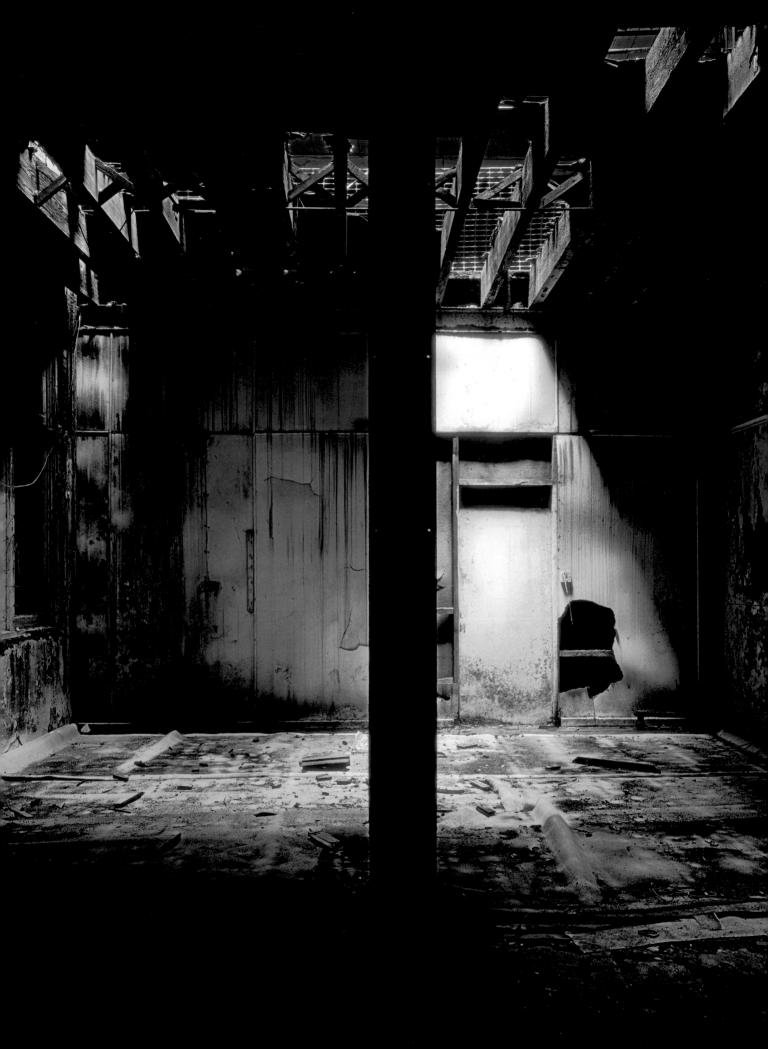

Some of the walled up sites found in Ancoats hold a quite unfathomable atmosphere. Later we came to understand that some of the sites were more interesting and more significant than others. What distinguished particular sites above the others was that something made the hair on the back of your neck stand on end, and didn't fizzle away either when they were opened or when they were sealed up. These particular sites were more akin to a source than a container. It is from these sites that the Peeps emerged.

The Total Abstinence Society of Miles Platting, Ancoats, established 1834.

One of the founders, Dr Ralph Grindrod was the principal spokesman. He was a natural orator and publicist, whose book *Bacchus* and lecture tours drew large crowds and many converts. In the 1840s he claimed that 200,000 people signed the pledge.

66 | 67 THE PEEPS: THE PRESENCE OF ABSENCE

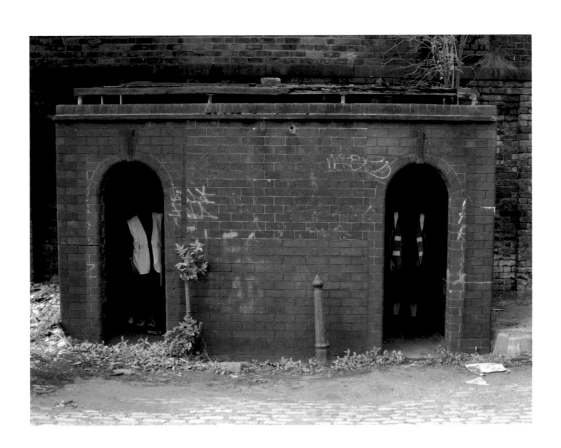

The cotton industry is inextricably linked to slavery, although at the time when Ancoats was thriving slavery was abolished in Britain. The so-called Atlantic trade triangle brought goods from Britain to the west coast of Africa, where they were exchanged for slaves. They were then transported in appalling conditions to the New World. Royal Navy sailors said a slave ship could be identified up to 10 miles downwind by its smell. Those who survived the journey then faced a lifetime of work mostly on plantations growing, among other crops, cotton.

In the mid eighteenth century as many as 50,000 slaves were transported annually by British ships. Although in 1807 the slave trade was abolished in British colonies and the carriage of slaves in British ships made illegal, it was not until 1833 that slavery was abolished under British law.

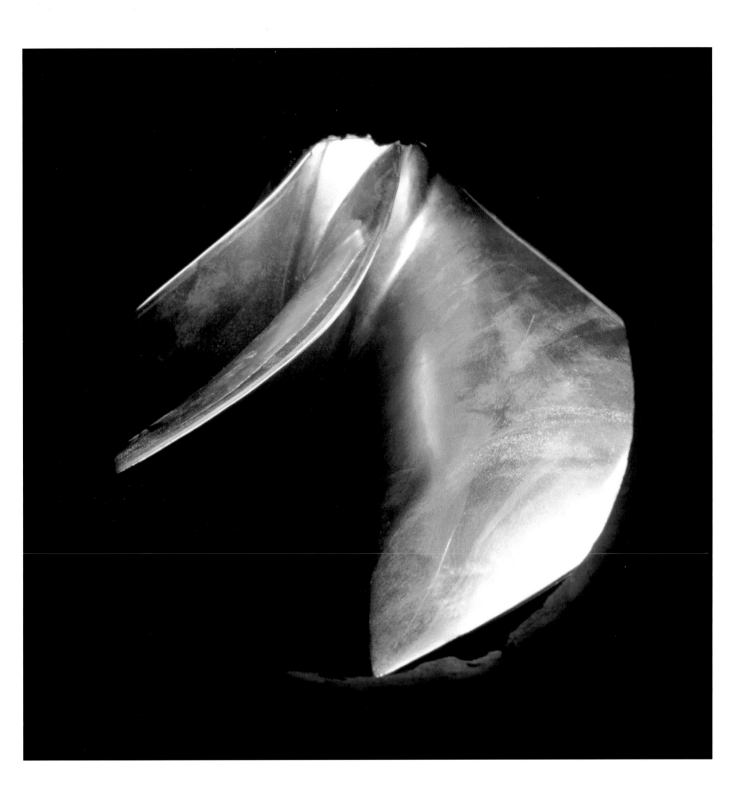

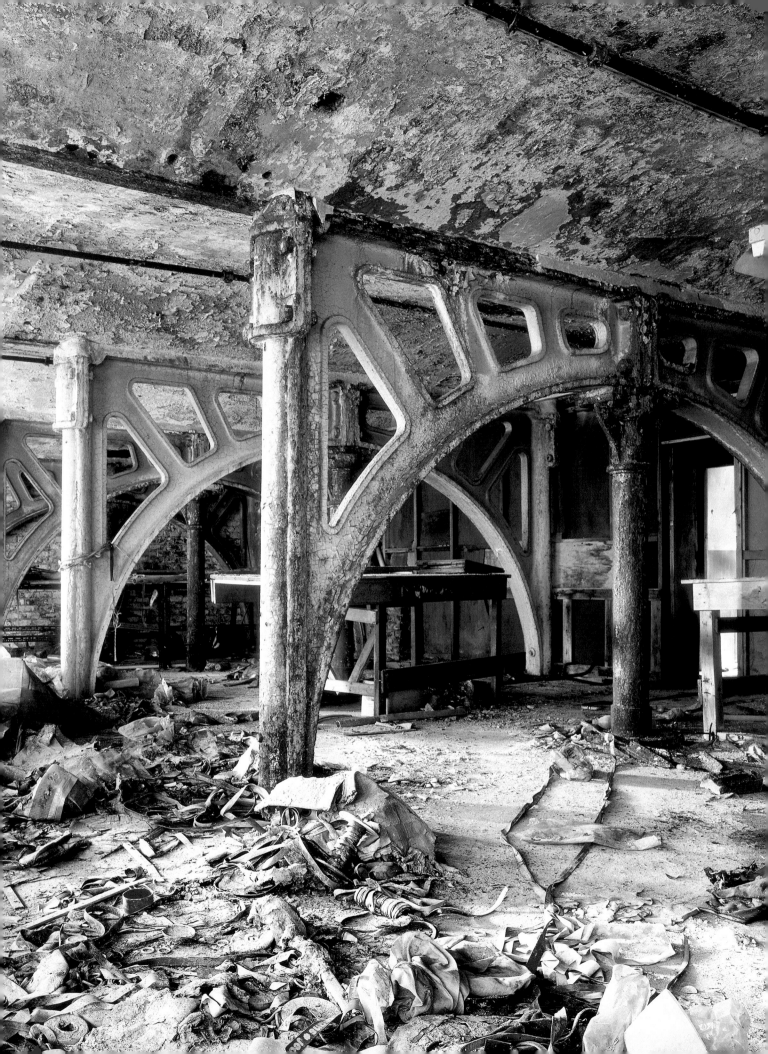

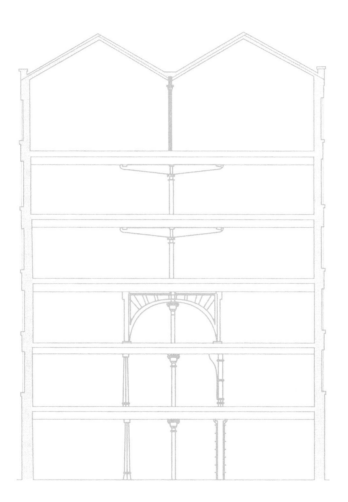

The first trajectory: the old could and would make way for the new in Ancoats, but also indiscernible mechanisms, and a series of spaces that had inexplicably been retained thus far could... and should be walled up – immured as the area is rebuilt and given the quietest yet most resonant of voices.

Maybe we need not try to preserve anything. Instead we can build on existing places and mechanisms, and build them into the redevelopment as living, breathing structures and mechanisms.

Project sketchbook notes.

The last remaining walkway in Ancoats was given planning consent for demolition in the summer of 2003. The mill buildings on either side were coming under separate ownership, and the lawyers for both parties wanted rid of the liability. The walkway didn't qualify for protection from demolition by the listing process, but the regeneration group recognised the value in trying to keep the structure. However without a clear function for the walkway they could not see how a case could be made to keep it.

Later in 2003 an artwork proposal was accepted based on retaining in perpetuity some of the 'lost' spaces in Ancoats, and it included the overhead walkway. Just as the scaffolding was being erected the developer agreed that the walkway could be retained.

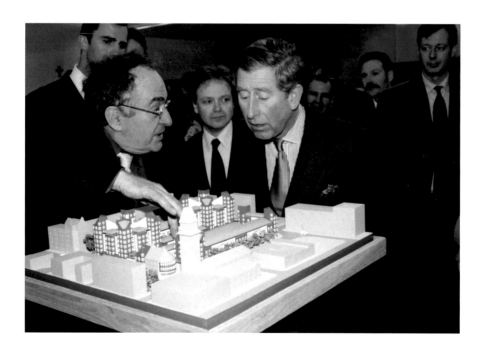

The Union & Co-operative Intelligencier in 1832 stated: "Who does not consider the use of machinery as one of the greatest evils there ever was in this country? Who should not rejoice at a return to the simple ways of work which allowed people to be healthy, happy and contented?"

"A thick, black smoke covers the city. The sun appears like a disc without any rays. In this semi-daylight 300,000 people work ceaselessly. A thousand noises rise amidst this unending damp and dark labyrinth ... the footsteps of a busy crowd, the crunching wheels of machines, the shriek of steam from the boilers, the regular beat of the looms, the heavy rumble of carts, these are the only noises from which you can never escape in these dark half-lit streets ..."

Alexis de Tocqueville, *Oeuvres Completes*, 1835

Whilst the engine runs, the people must work – men, women and children yoked together with iron and steam. The animal machine – breakable in the best case is chained fast to the iron machine, which knows no suffering and no weariness."

Dr J P Kay, secretary to Manchester's Special Board of Health, 1832

"So, what can you see?"

"I can see an old clocking-in clock."

"Really, let me see,... oh yeah... do you think that's really in there?

"No its too old, anyway there's a business in there now, and it looks like a photo to me. Let me see again."

"It not a photo."

"Yes it is, look there's no room for it to be there."

"Well if it's a photo how can it be telling the right time?"

"It can't be."

"It is."

"That's just a coincidence. It must be taken at 2.20."

"It says 2.22 now."

"Shit. You're right......"

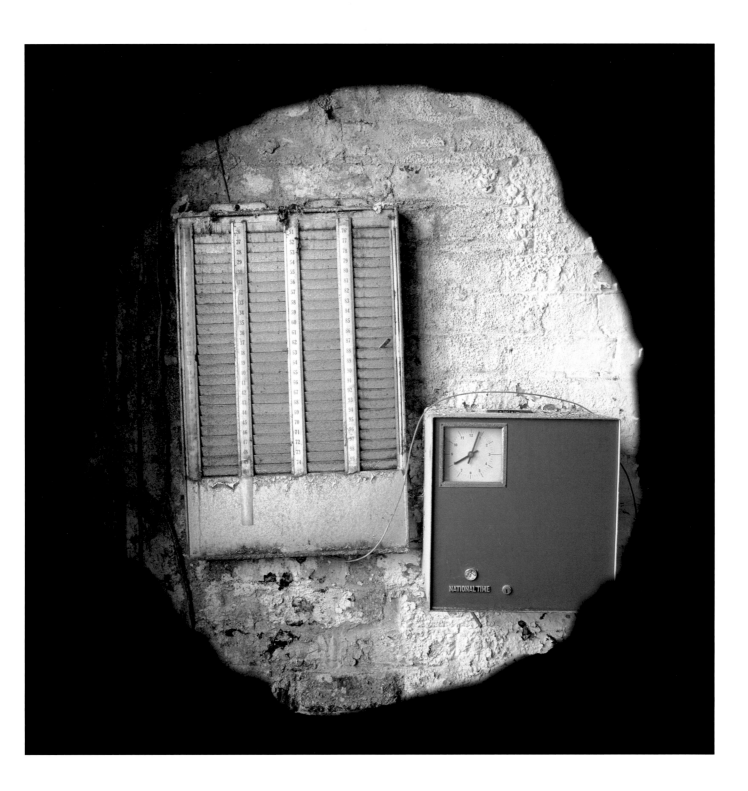

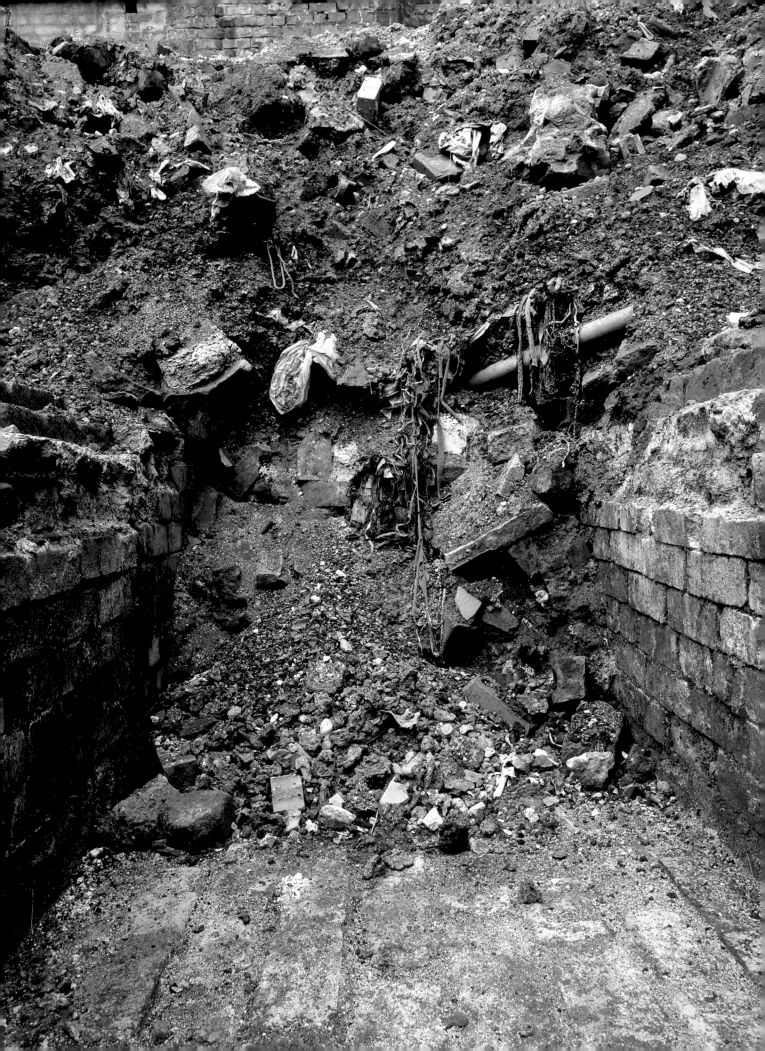

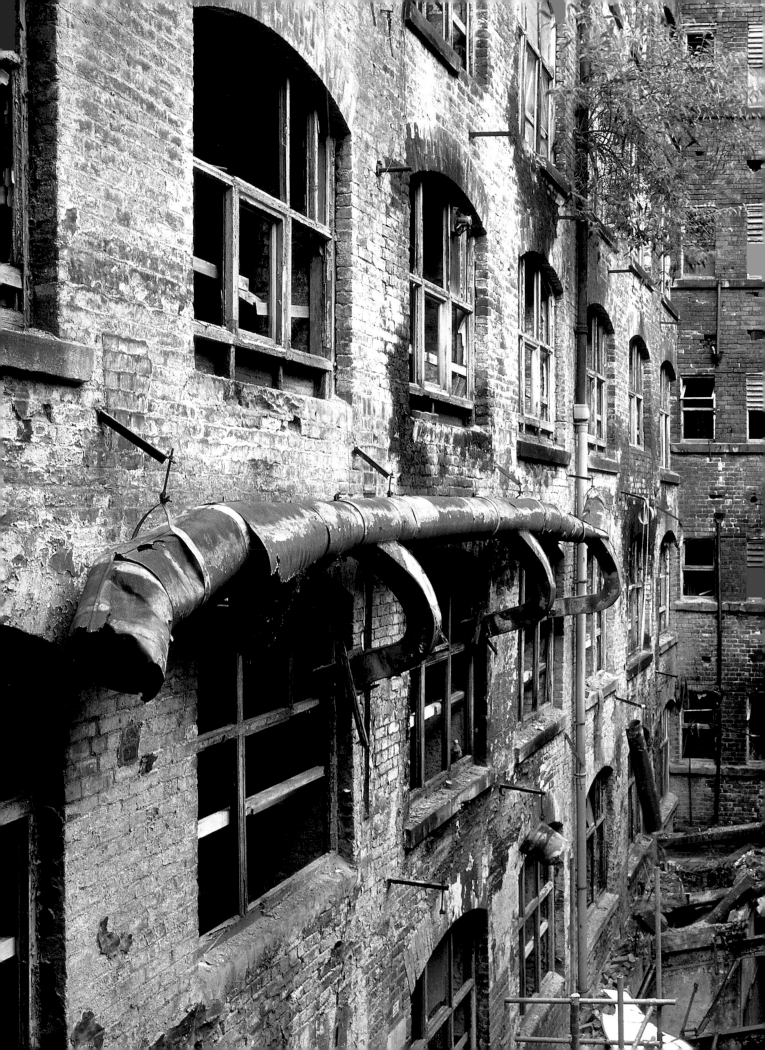

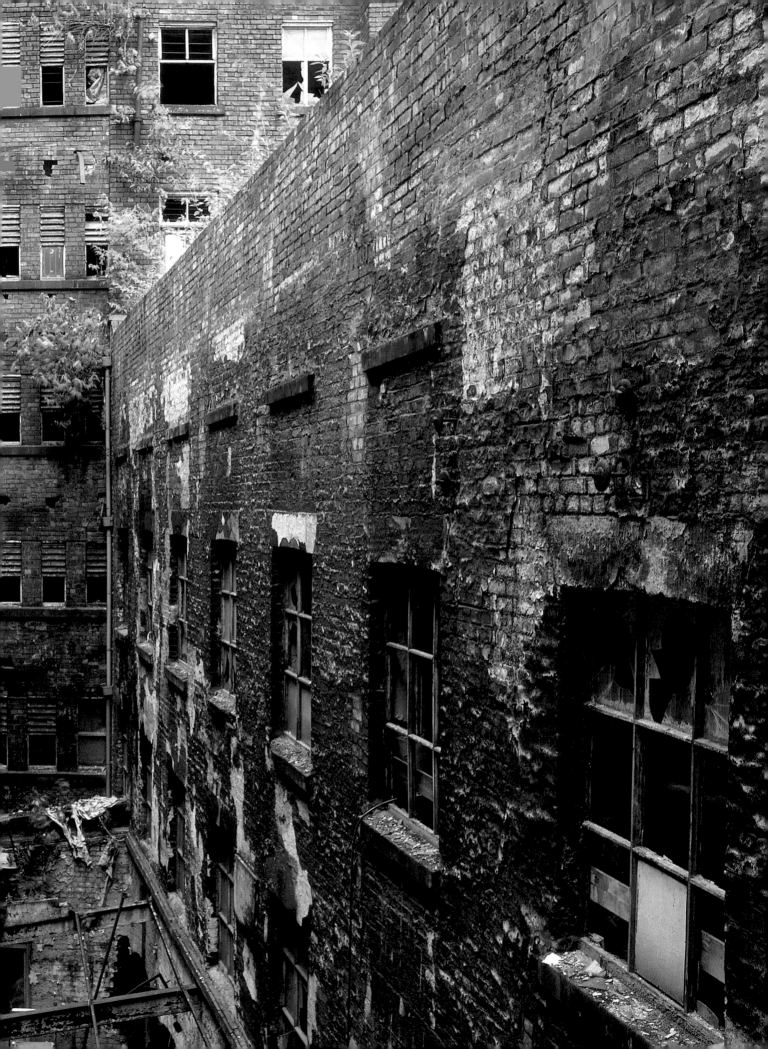

For an important structure, a tower, a fort or the walls of a town, there are a range of medieval myths, Europe wide, whereby the master mason might make a sacrifice. Often it was his daughter or his wife. Less malevolent are the relatively innocuous traditions of immuration: walling up a child's shoe at a threshold, a horse's shoulder blade in a hearth, coins in an attic, iron at a doorway.

These disparate traditions and rituals share a belief that building a place that will stand up involves a wider understanding and empathy than is defined by structural calculations, planning and building regulations. Implicit in these immuration rituals is the notion that for a structure to be sound, for a place to stand up, to serve its inhabitants well, it must also respect and accommodate other more intangible forces.

If Ancoats is no longer about cotton spinning, if it is no longer one of the densest and most productive industrial suburbs since the industrial revolution, then what is Ancoats for?

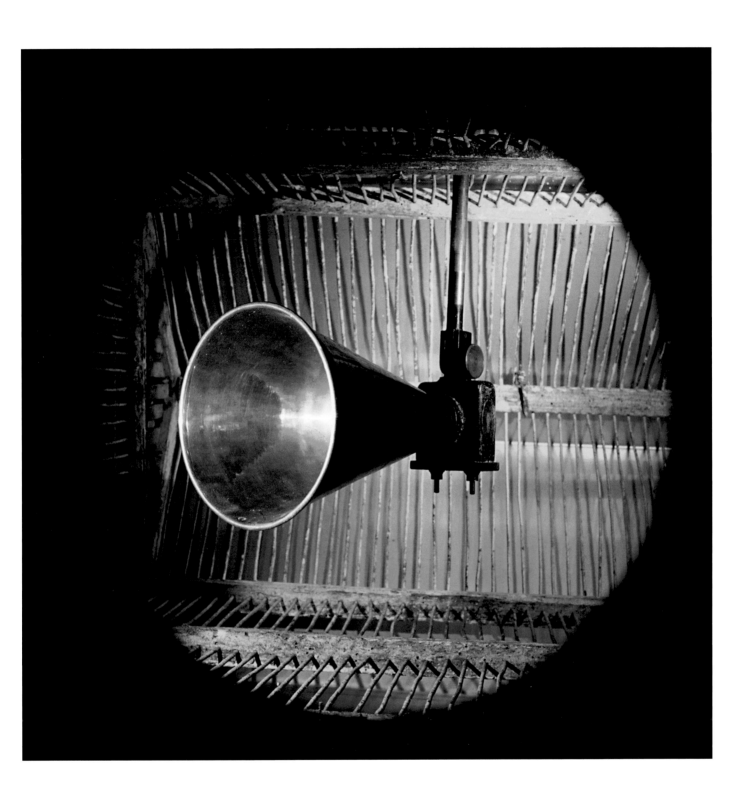

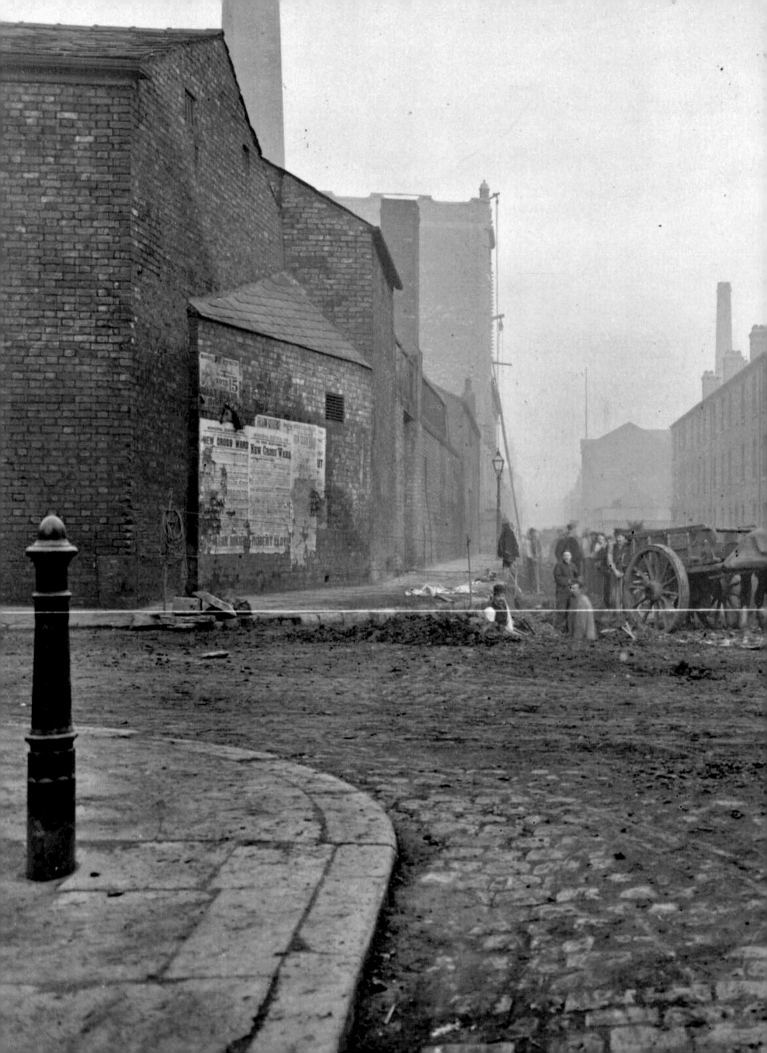

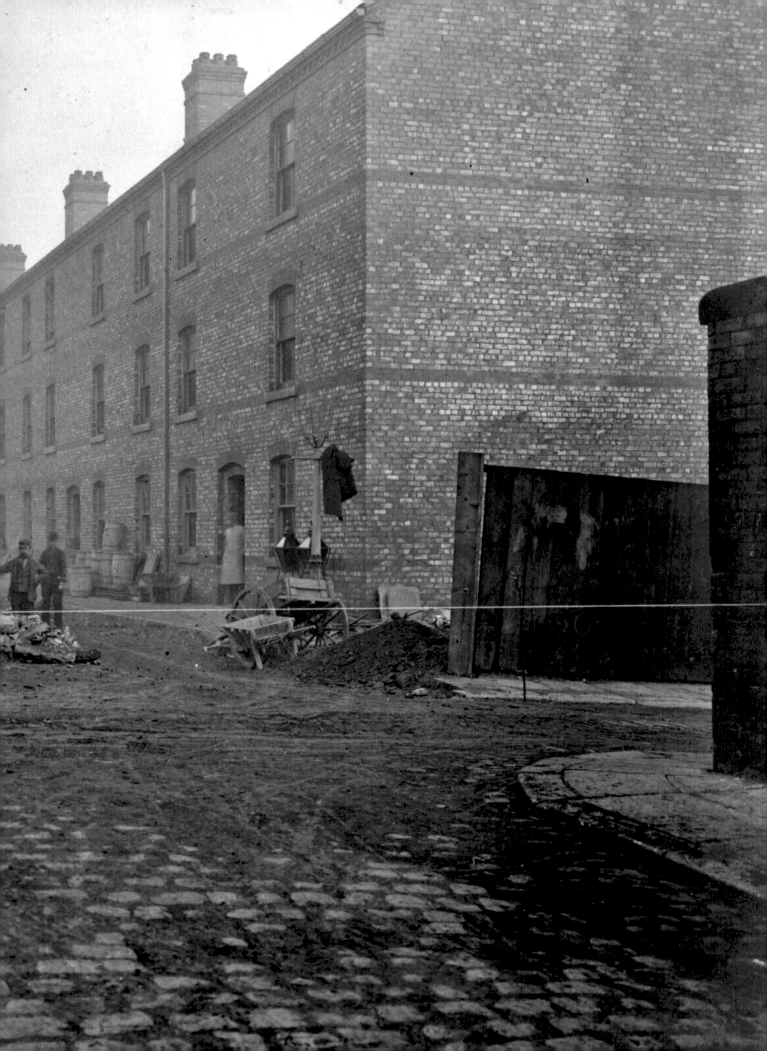

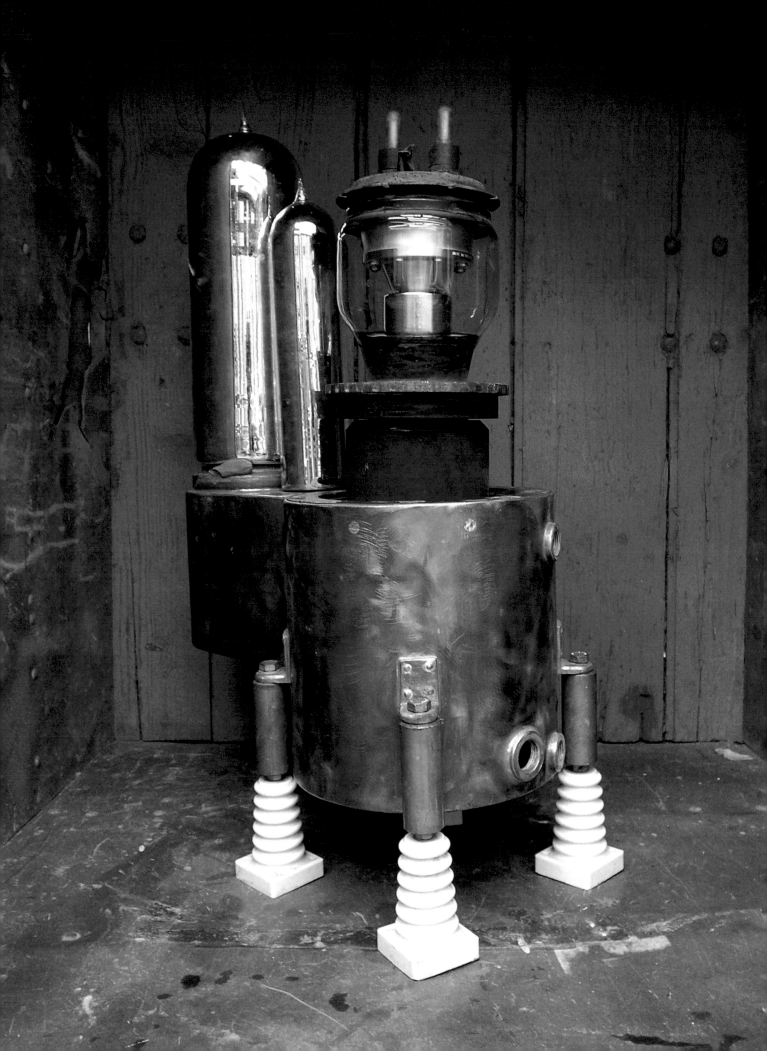

The Murray brothers from Glasgow were originally clock makers. They applied their knowledge to the design and manufacture of cotton spinning machines. They then built their own mills in Ancoats for the machines they had developed. Their looms and Ancoats' industry grew out of much more intimate and jewel like mechanisms.

Throw the nut

The stalker navigates his charges through the zone. A post industrial landscape reclaimed by nature. They are in search of 'the room' which is reported to have magical properties, when the stalker finally gets close to the site he lies down on the ground and dreams for a while. When he gets up he spins a metal nut on a ribbon as a means of divining which path to take to the room, he then heads off arbitrarily in another direction altogether that does not lead directly to the room, explaining that there are no straight paths in the zone.

Scene from Tarkovsky's film, *Stalker.*

Synchronicity is the simultaneous occurrence of events that seem to be meaningfully related but are not explained by conventional mechanisms of causality.

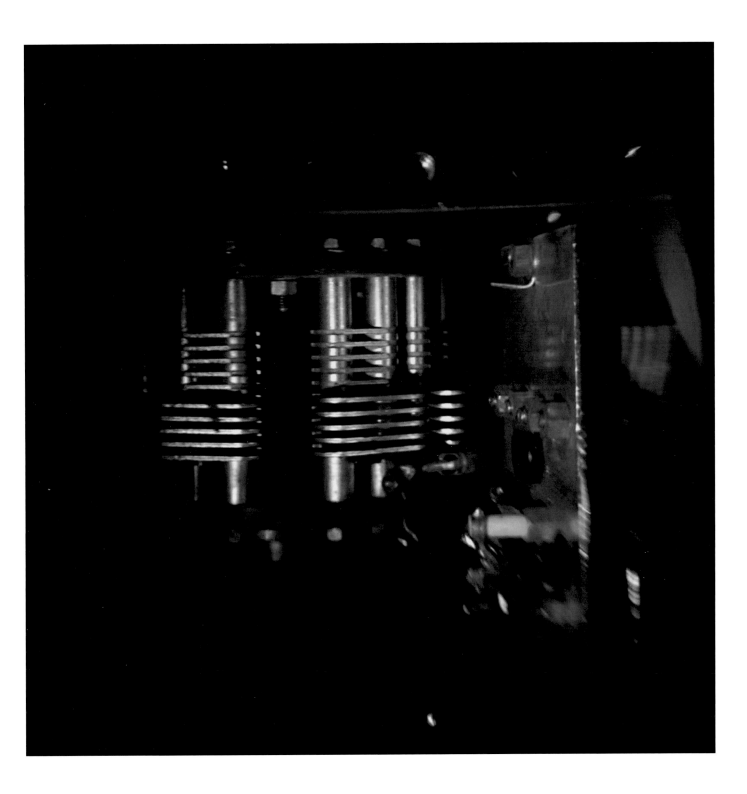

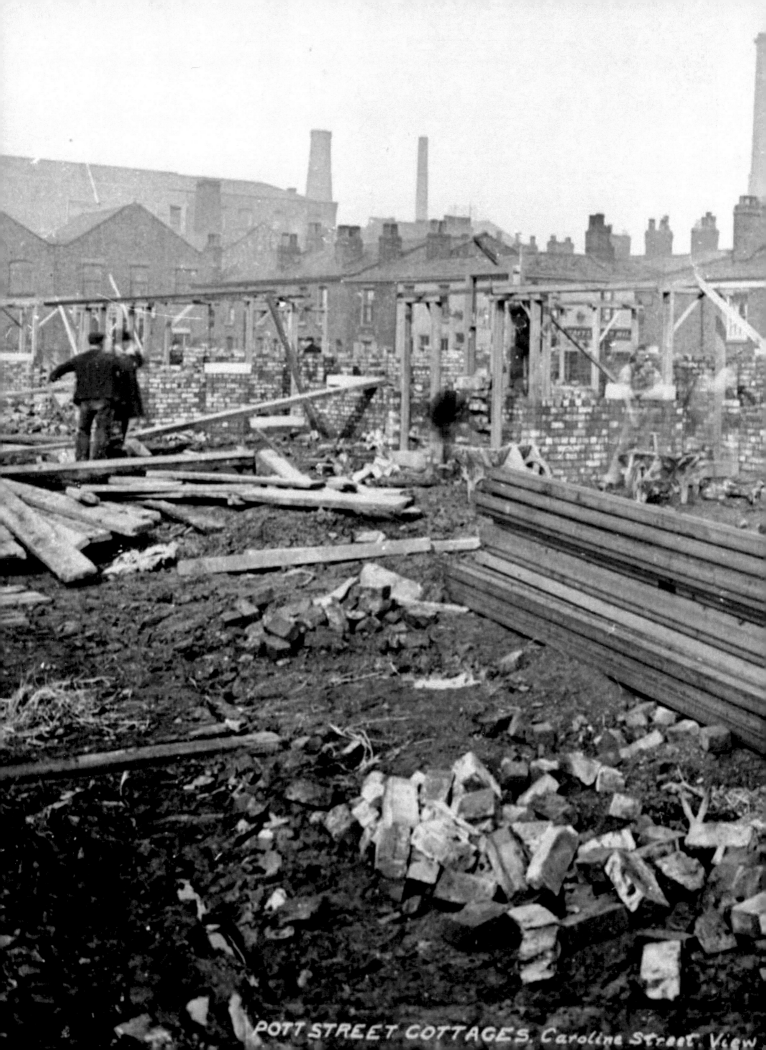

POTT STREET COTTAGES, Caroline Street View

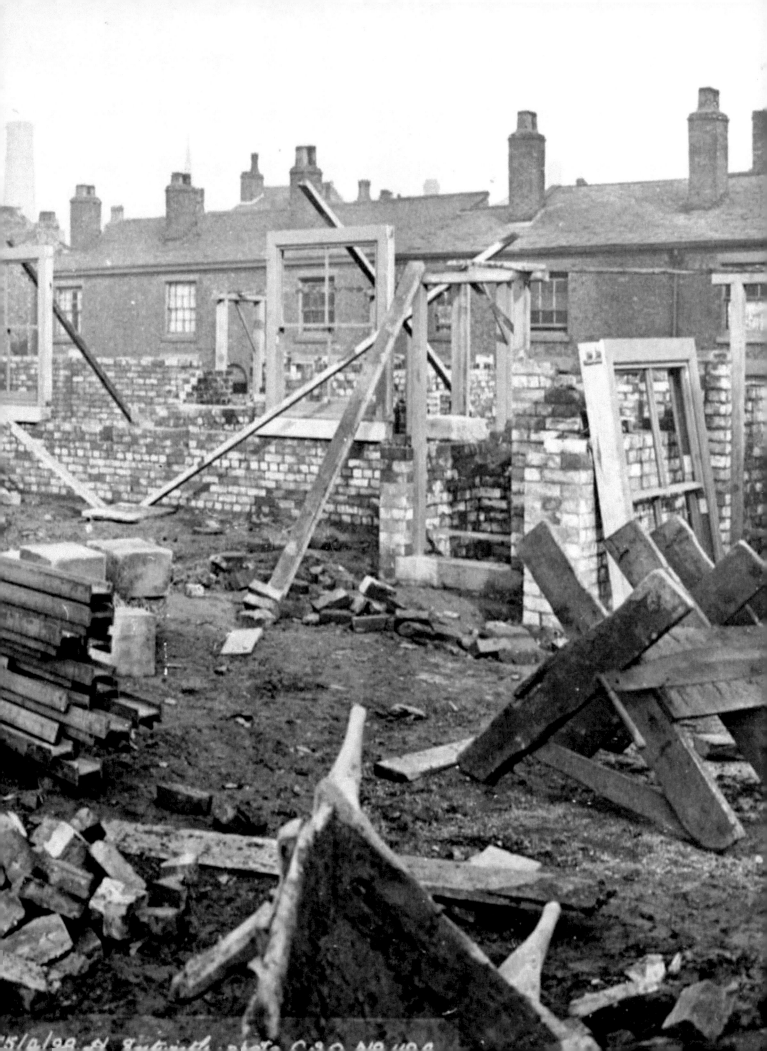

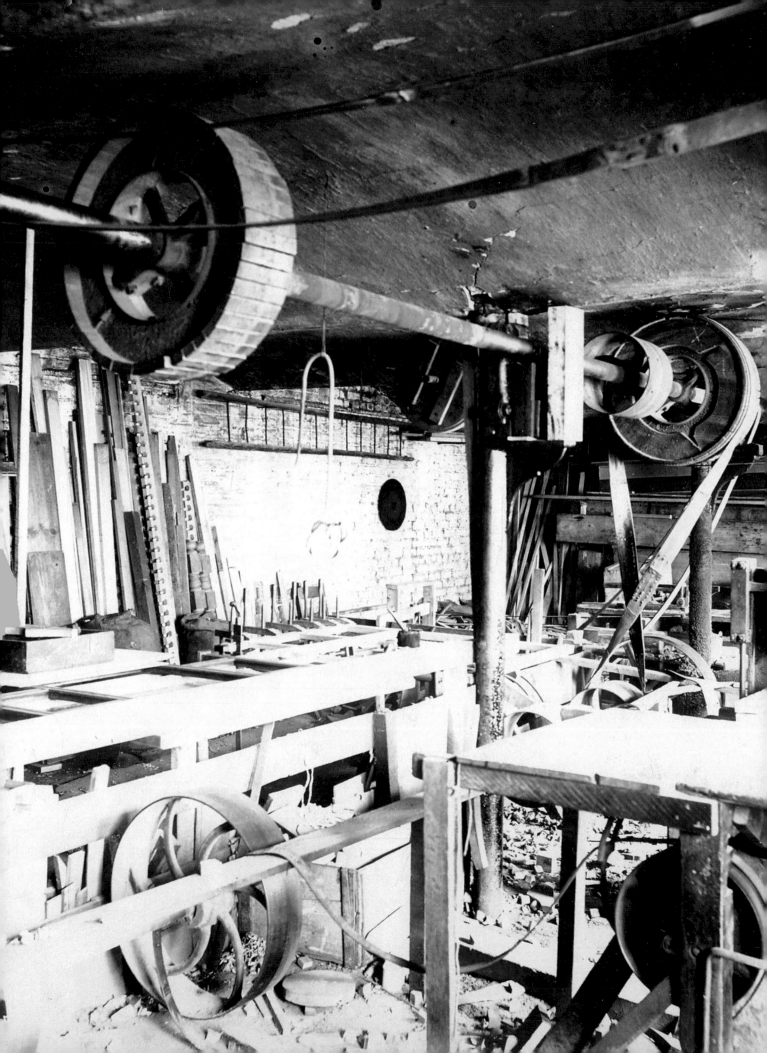

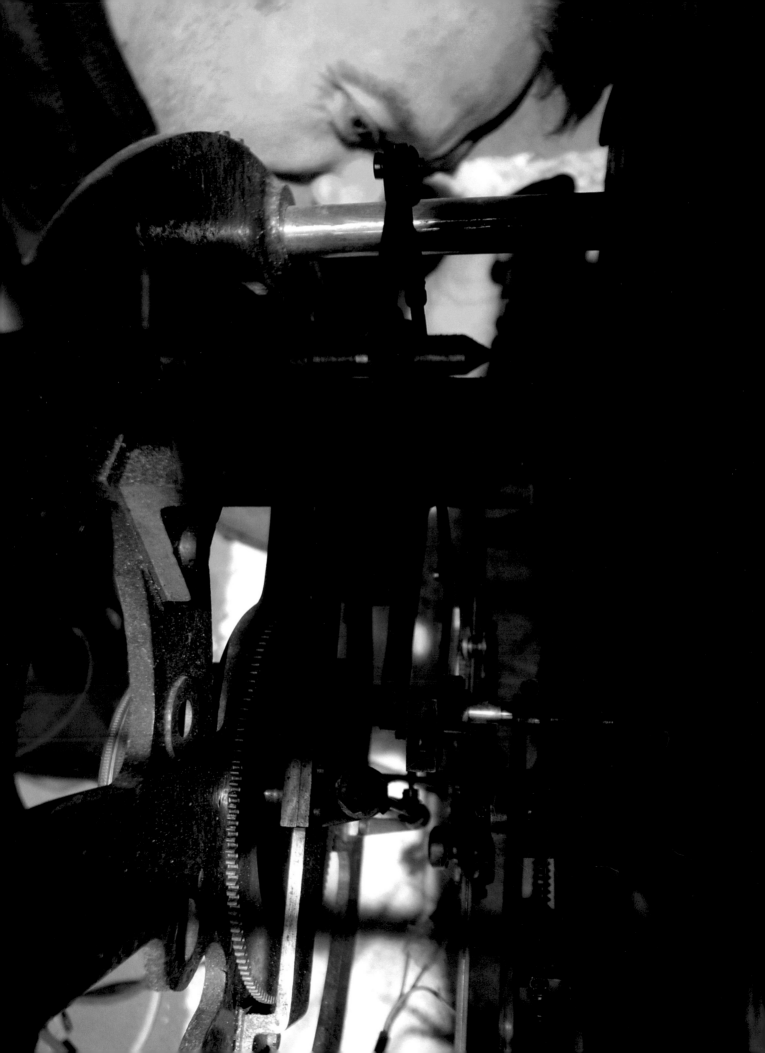

A portrait of Sophia Loren looked over the ladies as they sewed. Behind her was a small kitchen sporting three notes from the management asking in different ways to save electricity. There was also a list of names and how many sugars each of the ladies took in their tea.

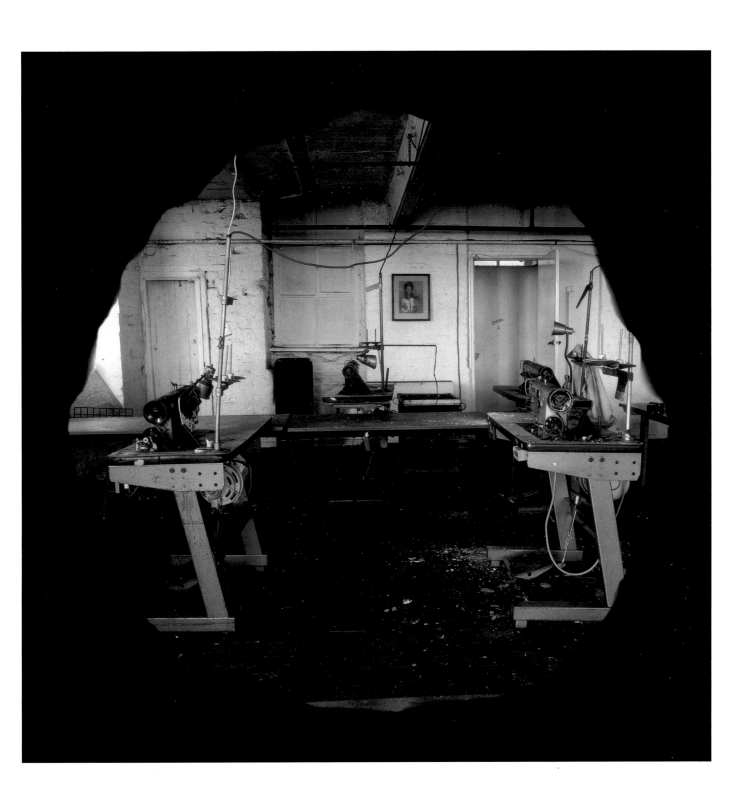

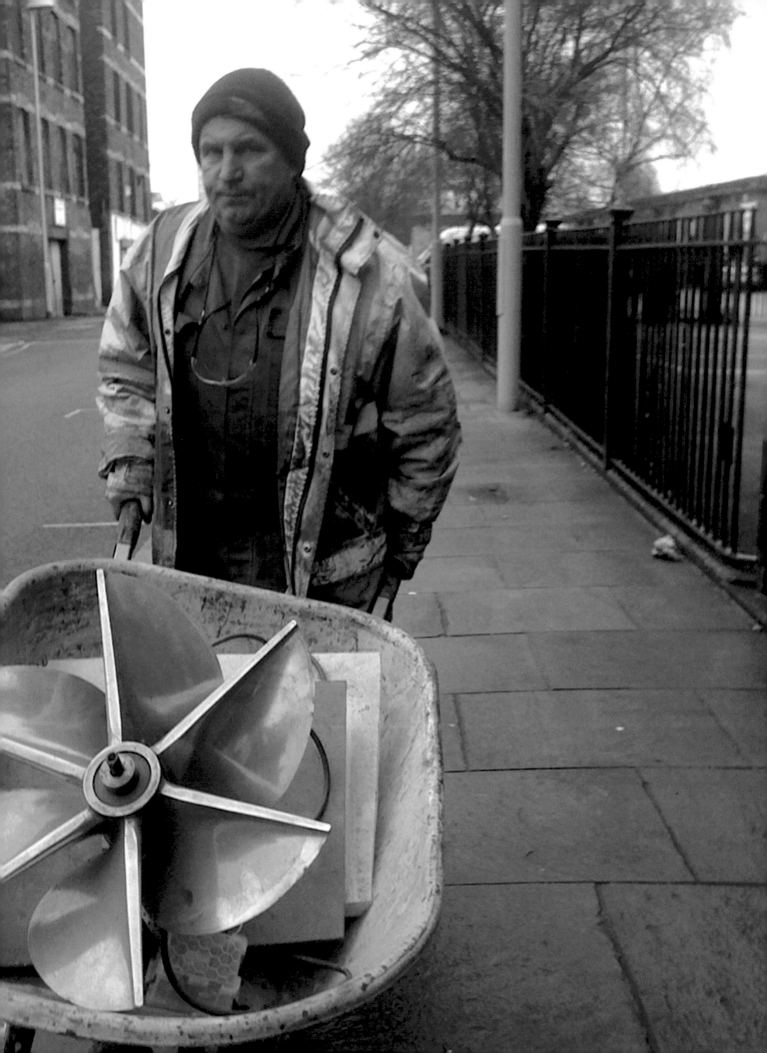

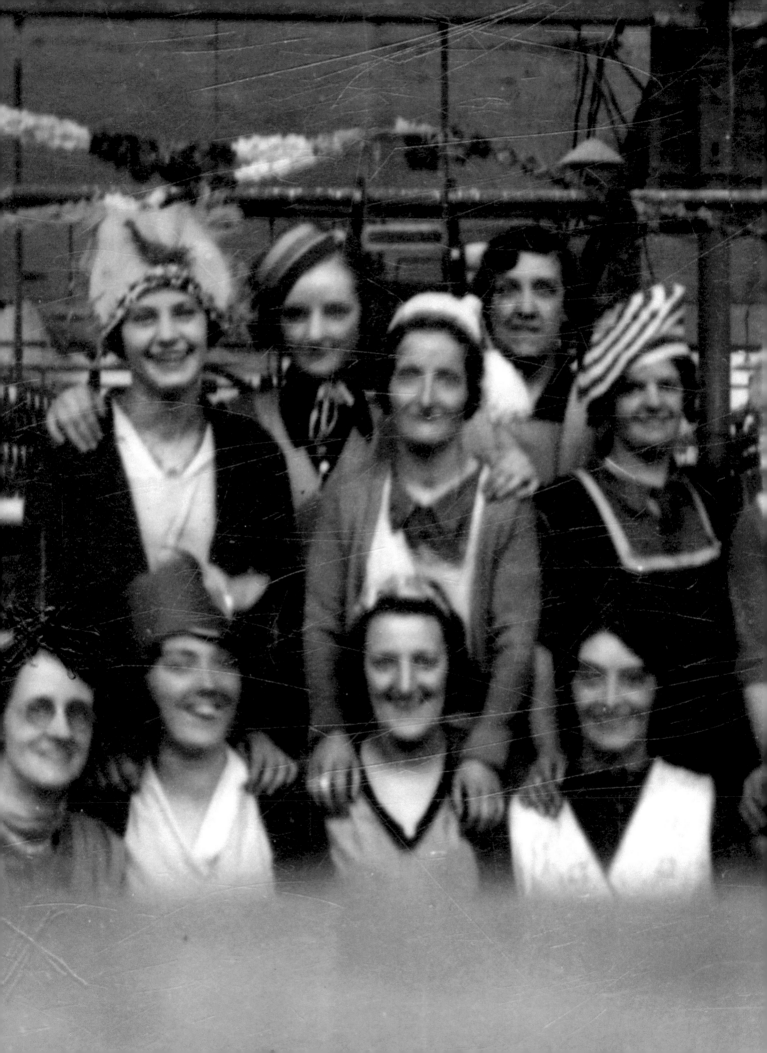

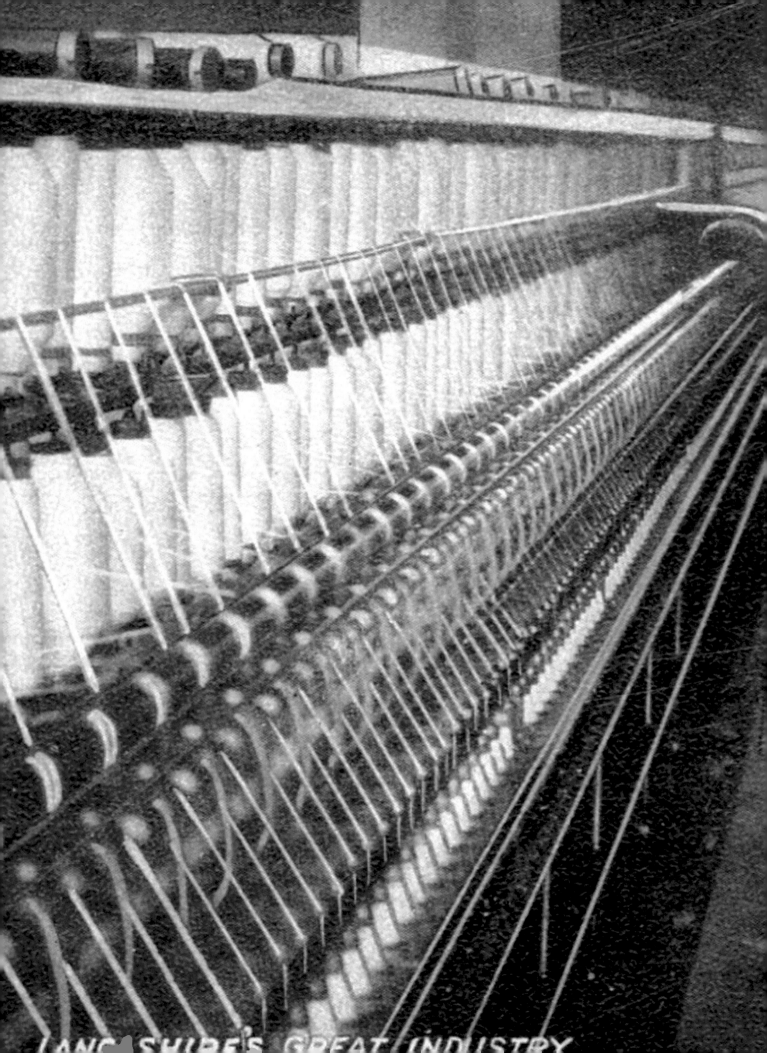

LANCASHIRE'S GREAT INDUSTRY

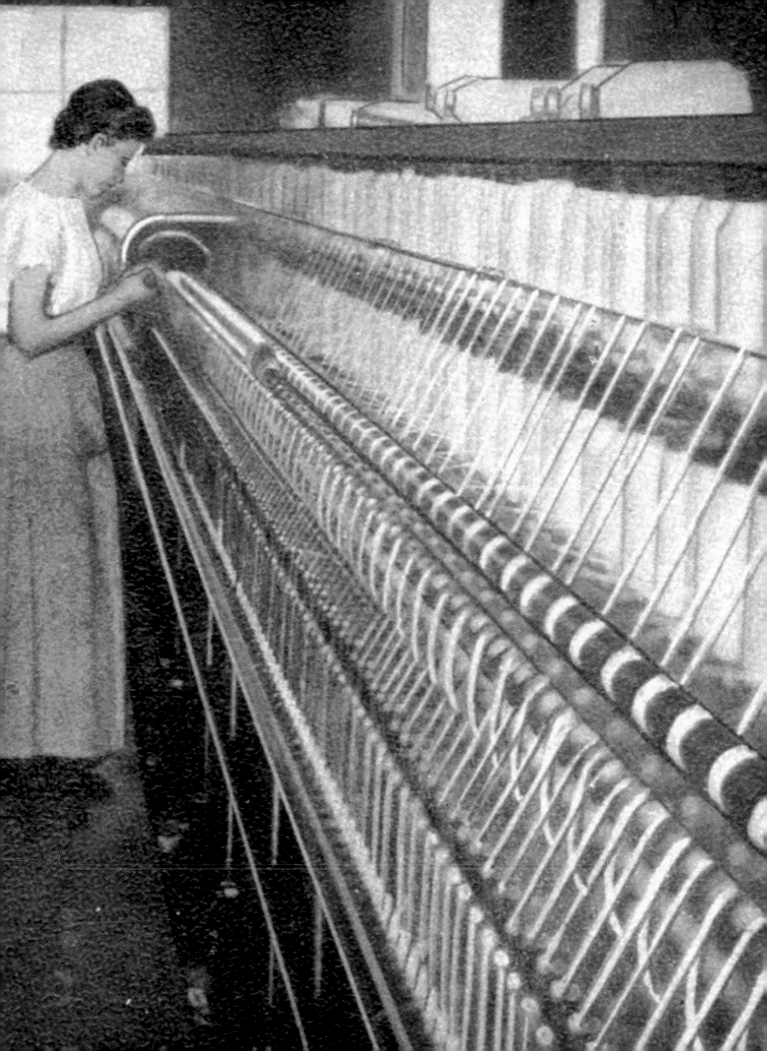

"ancoats was at its tipping point ..."

It was also turning itself inside out and stripping itself bare

In 2003 I joined a small group tasked with re-establishing a public realm in Ancoats. We were working in the context of a UK national urban policy to regenerate inner city wastelands. In Ancoats we shared an optimism and confidence that we would be working on this place for the long haul; maybe 10 years, maybe more. For an artist, the opportunity to be engaged in the remaking of a place from the outset, and in a way that can be sustained over a decent amount of time, is a privilege and opens up a rare opportunity: the possibility to try and find out how an artist might meaningfully be involved in city scale regeneration.

It was only a few months into the project, I was just settling into the studio and getting my bearings, when I was rudely awoken one dawn by an almighty crash. As I looked bleary eyed out of the studio window onto Murrays Mill, I saw sewing tables, then machinery, then boxes that spilt their loads into a plume of buttons, needles, belts, labels, neck ties, school uniforms as they hurtled towards the ground. Next it was rolls of fabric, then the trolleys, then the doors, then the partition walls, and then I picked up my camera and got over there. In Manchester this is known as ditching; a team of men some characterised by their unemployability as unskilled labourers, were armed with crowbars and clubs and were stripping out the building floor by floor. A giant hole was knocked out down to the floor of each of the eight levels, and the contents of each mill floor was carted to that end, everything was then hurled out into the courtyard until the mill was stripped bare, then they moved to the next floor. I introduced myself to the foreman of this and the other sites where ditching was soon underway, and armed myself with my camera and grabbed a box of red patent leather belts. I went into battle, dawn to dusk saving what things I could as I moved along with my camera and note book, by tying a belt around things otherwise headed for the skip, trying, often in vain, to stay one floor ahead of the ditchers.

> With a sudden jolt the regeneration process had shifted into action.
> Ancoats was at its tipping point, it was also turning itself inside out and
> stripping itself bare.

The artworks for the regeneration of Ancoats made during the first year were collectively titled 'The Presence of Absence'. They centred around a series of photographs of the mills and interviews with former mill workers, owners and residents now dispersed around the city. By the time they were complete I felt that not only had I got under the skin of what Ancoats was about but also that the place had got under my skin.

Soon my work in Ancoats began to change.

The rescuing of 'junk' (or 'treasure' depending on your perspective) was an attempt to retain a few elements, mechanisms, totems, and it got madder in scale very quickly. In no time the studio was jam packed and I began to negotiate with the new owners and the ditchers to retain areas in the basements to store things. Then I began to ask for whole rooms to be left untouched, particularly those that had been walled or locked up.

Saving stuff was the beginning of something. Although I could see it was not an obvious part of Ancoats' new trajectory, nevertheless in this activity there were clues as to what, as an artist, I might do here.

The Presence of Absence artwork had revealed some of what was latent in the area. What followed was a compulsion to engage and intervene directly in the changing fabric; to address what was being ditched. It was an intuitive act, but one that marked out a new phase for the project, one in which I would move on from witnessing and reflecting, to personally intervening in the fabric of the area as it changed. The time in the studio was spent trying to fathom what shape any intervention could meaningfully take.

Living and working amongst these behemoth cotton mills my attention was drawn to the unexpected vestiges of life in different forms carrying on in the mills in spite of the area being all but shut down. It made the hairs on the back of my neck stand on end with each new find. These disparate and strange mechanisms, walled up spaces, phenomena that lingered on in unexpected sites around Ancoats had a collective identity somehow. I realised Ancoats was still living and breathing in the deepest recesses, in little caches. My challenge it seemed was to establish, against the clock, what to make of these experiences and sites, and if possible establish how some of these charged spaces and mechanisms could be nurtured. How they could survive the cleansing phase of the regeneration? What would I be retaining? Why? What place would a walled up space or mechanism have in the emerging identity of Ancoats as the reconstruction of the area took place?

As I began to grapple with these questions in the studio I entered another phase of the project. In addition to the close working relationship with the design team for the public realm, I embarked on a series of creative collaborations and dialogues to develop ideas for the project. These were with artist/architect Dan Wrightson, Professor of Artificial Intelligence Noel Sharkey and artists Mary Wardle, David Ralston and Pickle Ellison. Each brought a unique creative perspective to the project, shaping the Peeps as they unfolded.

* * *

When the roads and pavements in Ancoats began to be torn up, not only were cobbled streets revealed but a walled up tunnel was discovered that once joined two mills. An overhead walkway and a walled up public toilet embedded in a historic bridge were also on our radar as their demolition was imminent. It was a natural progression from retaining artifacts and rooms to want to hold on to these fascinating finds, but this level of hoarding was a complex and difficult undertaking. If not a little mad.

Who would own them after they were retained? What would be done with them? Why? By whom? For what purpose? At what cost? These questions needed to be answered almost immediately or these spaces would soon be lost.

I threw up the bat signal at the studio and convened a summit of project collaborators, and although none of us could quite explain or articulate why we would pursue such an unusual and unprecedented course we were in agreement that it was somehow the right thing to do, to make something of these finds. These isolated walled up spaces had miraculously survived the degeneration and ditching. They were the spaces of the ordinary everyday activities of a working industrial city and suburb; places to eat, move, pee, produce, and they were unexpectedly highly charged and somehow extraordinary by consequence of what had become of them. As people in the area began to hear about these found spaces, their arrival in people's consciousness seemed to add a new layer to Ancoats. Knowlege of these spaces changed immediately people's sense of what the area had been and what it could become. Their impact on the psyche of Ancoats owed as much to the stories and myths that began unfolding around each find, as did the experience of witnessing the spaces personally. Additionally we began to recognise that these places seemed connected to one another somehow, they were a series, a set. Each was a discrete site with its own character and story, but collectively they created a network of connections to one another and became more than the sum of their parts. So we agreed on a simple plan, and the Peeps project was born. If these walled up spaces could be experienced from the public realm, ie as you walk through the streets, then we should work together to make something of them.

How might an artist constructively be involved in shaping a city; in particular in making a post industrial landscape? While working on the regeneration of Ancoats, I was also working on cultural masterplan programmes in the UK for Sunderland, Scotswood in Newcastle and Stoke on Trent. In these city scale regeneration projects large architectural masterplans were being developed to provide a framework for the physical and economic regeneration. The cultural masterplan was developed as another layer to this framework that addressed how this physical regeneration would also effect a cultural transformation and lead to a new identity for the area. These cultural masterplans choreographed the individual and disparate physical projects of a regeneration, be they a street, a

public square, a bus station, a shopping centre or individual apartments. Re-tuned, a number of projects resonate with one another and develop stronger connections. This allows for these projects to become more than the sum of their parts; combined they have the possibility of constructing new identities and effecting a cultural transformation.

The regeneration in Ancoats was very different to these other city scale projects where a cultural masterplan was commissioned. In Ancoats I started out as the artist making an artwork, not a strategic planner. This project is fundamentally different from masterplanning as it is characterized by thinking as doing; by working out the planning and direction of a project, by getting stuck into making things in parallel to pursuing the abstract working processes of planning.

Working on The Peeps and Cutting Room has lead me to a deeper appreciation of reciprocity; the notion that not only do we construct our built environments, but they also shape us and our relationships with one another. In developing these artworks I have the sense that there is the possibility of making something that moves people deeply when the artwork and the place being made are the same thing.

The real potential for involving an artist in the making or remaking of a city arises when the artist's role shifts from observing to intervening; when the artwork shifts from being reflective and passive, to becoming part of the built fabric as it emerges. This way the work develops the capacity to be active and transformative in sychronicity with the fabric of the city.

The Cutting Room and The Peeps are the means of presencing a series of immured charged spaces. As you walk through Ancoats, the presence of absence is not limited to being touched for a moment by what was once there. Peering into these shifting yet seemingly uninhabited spaces, the sense of presence is as strongly resonant of what might be coming, as to what has been.

Dan Dubowitz, Ancoats, 2011

NEW CROSS

CORNWALL STREET

LANCASHIRE. MANCHESTER. SHEET CIV. 7. 21.

SQUARE

THE
CUTTING
ROOM

FIRST EDITION, 1891.

Patterns were the templates from which cloth was cut. They were held in the pattern rooms, hung from the walls, an archive of clothes produced. Cloth to be marked for cutting was brought to a cutting room, which featured enormous, well lit tables. The pattern was collected from the pattern room and cloth was marked out with a chalk and cut. A few cutting and pattern rooms remained in Ancoats at the outset of the regeneration, one in particular, the last to be cleared to make way for development, was quite remarkable. It had been built into the attic of Royal Mills. The cutting room was vast and bright, and one end had been given over to a small locked room as a pattern store.

A fire had wrecked the roof and now mature trees were growing in the space. In the pattern room the plasterwork had long since been washed away exposing the brickwork but the patterns, made of a waterproof velum, remained vivid hanging from the walls. The patterns and the patina of the brick wall almost merged in the light of dusk and so I went back to photograph this space on midsummer's day and had to wait until late into the evening for dusk. While I waited I was aware not only of butterflies and birds but also of a rabbit.

In 2005 the public realm design team embarked upon making a new public square. There was no precedent for this in Ancoats, as Engels was eager to record. Space was either for production, trade or cramped dwellings. There was no free social space to be part of a community outside of school, church, work or the pub. In order to make the new public square, a site at the heart of Ancoats was acquired with a compulsary purchase order. It once accommodated a number of different businesses but latterly was mostly derelict and gap sites. This opened the possibility of giving over the site for permanent public use. Having finally achieved a new piece of open space, we faced the design challenge of making it a place that would draw people to pass through it and others to congregate and stay a while.

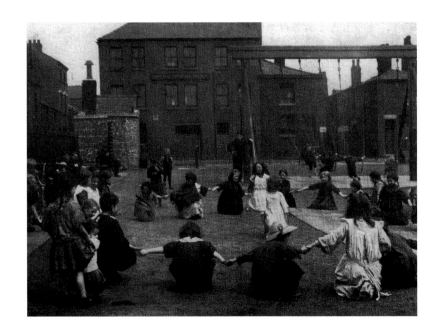

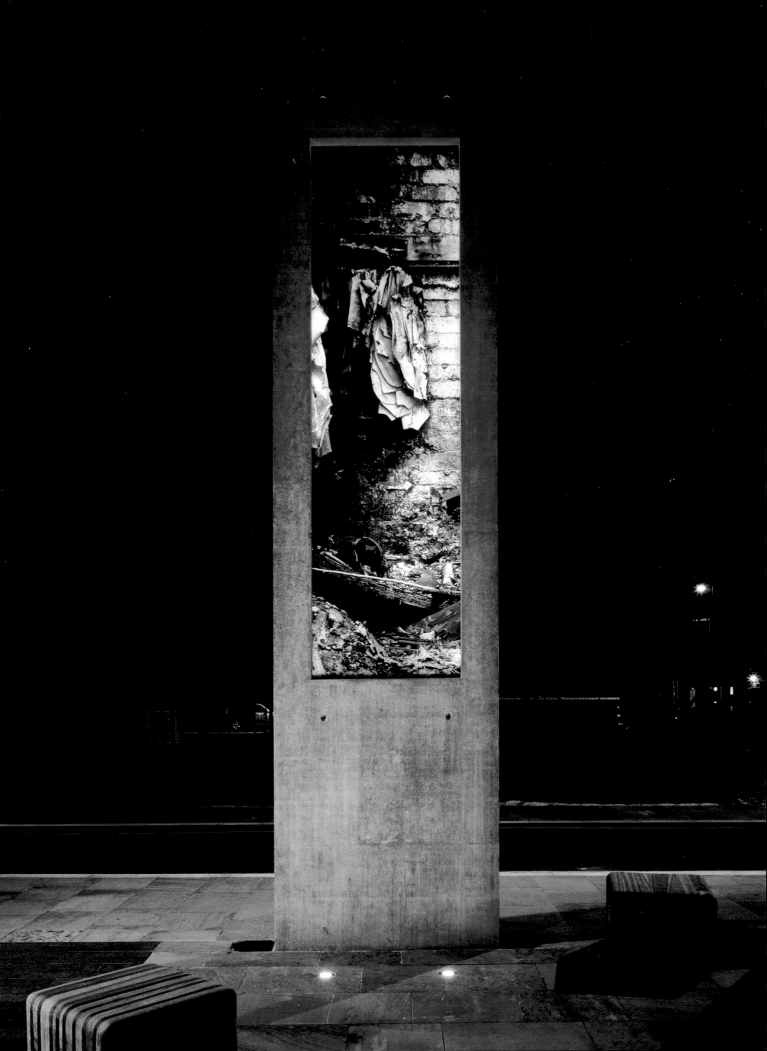

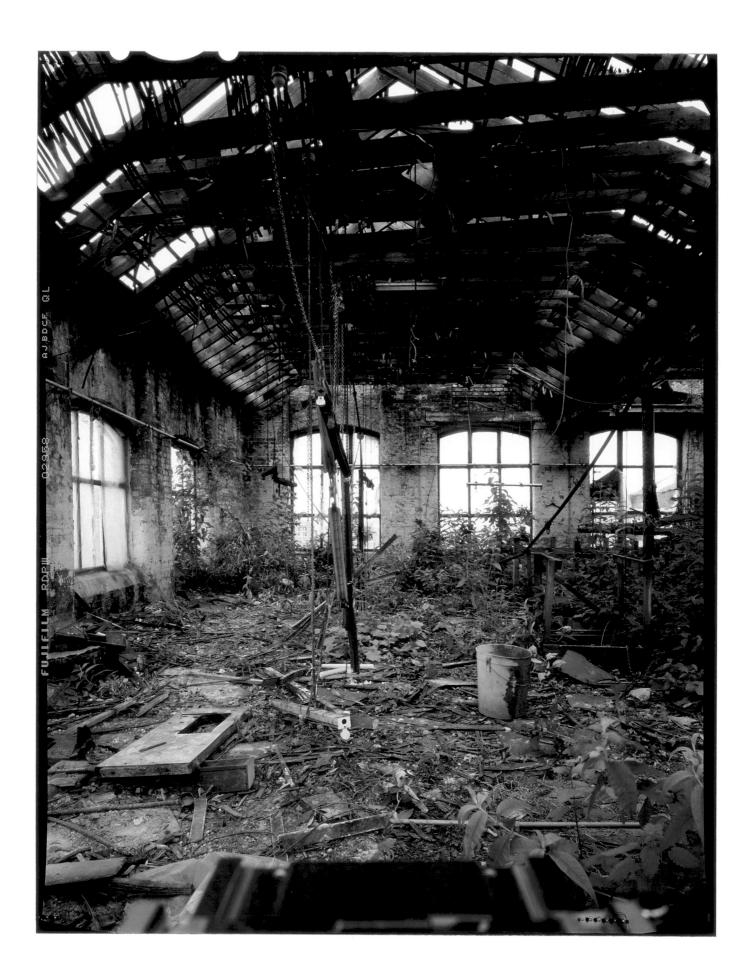

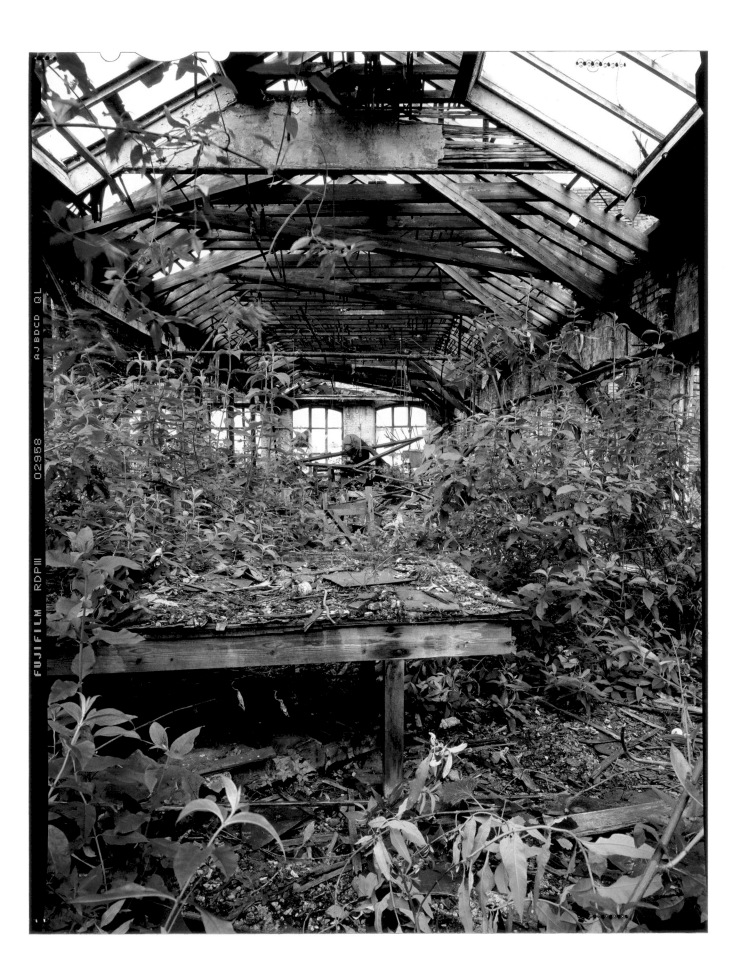

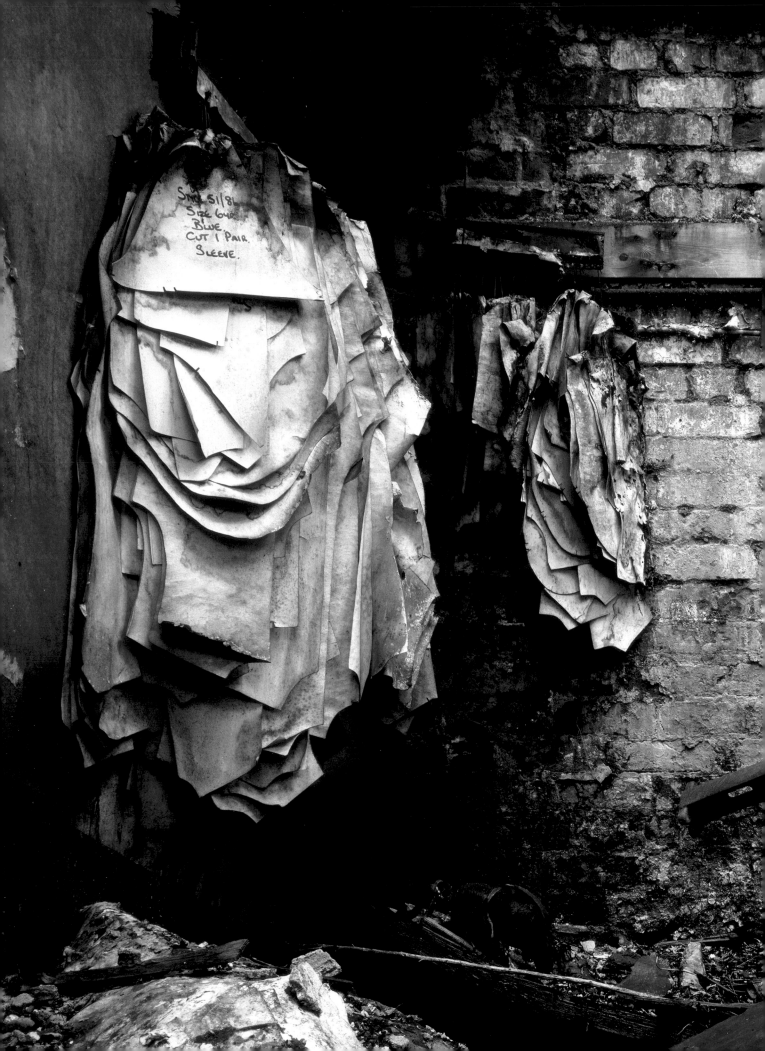

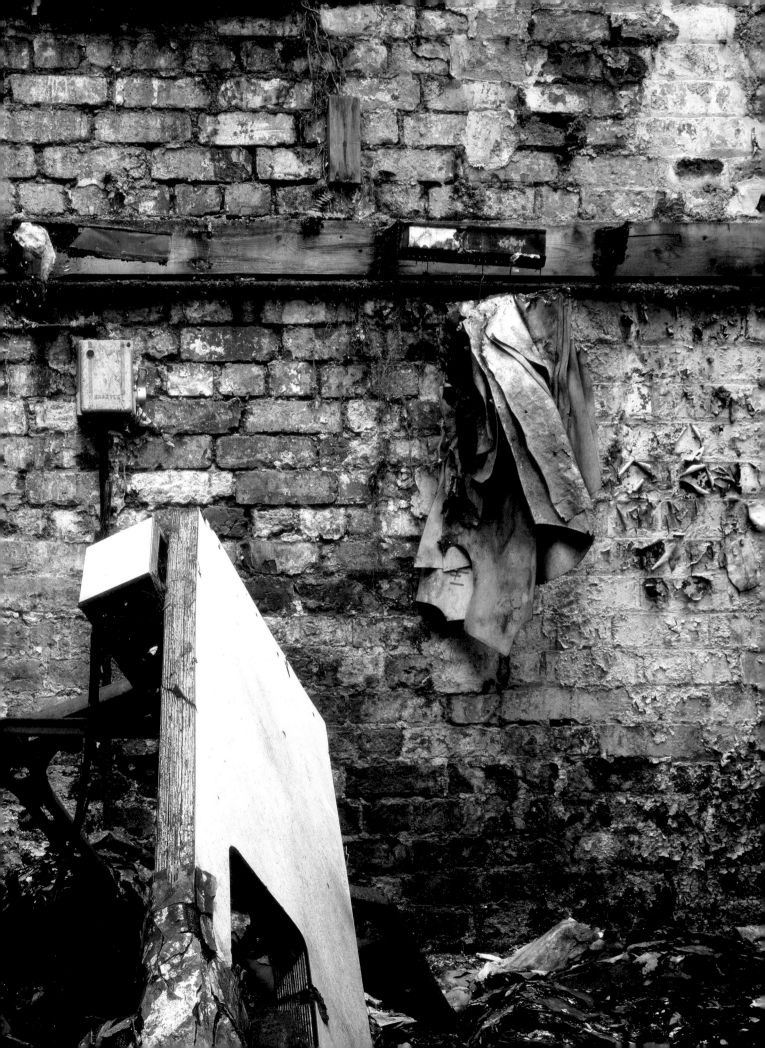

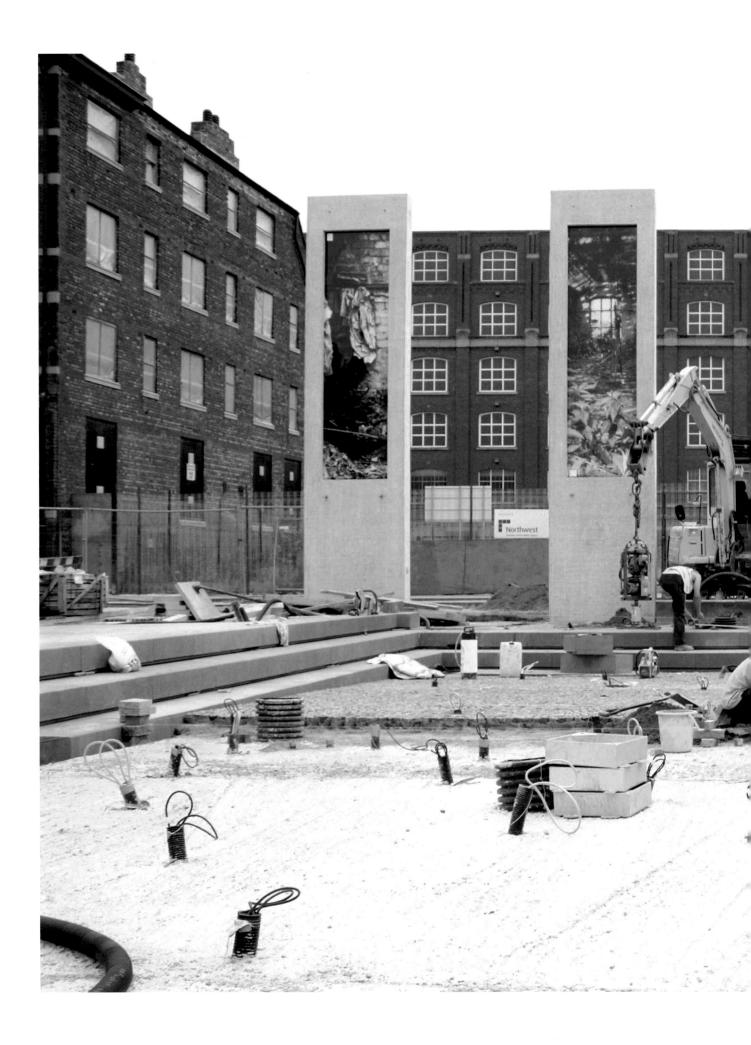

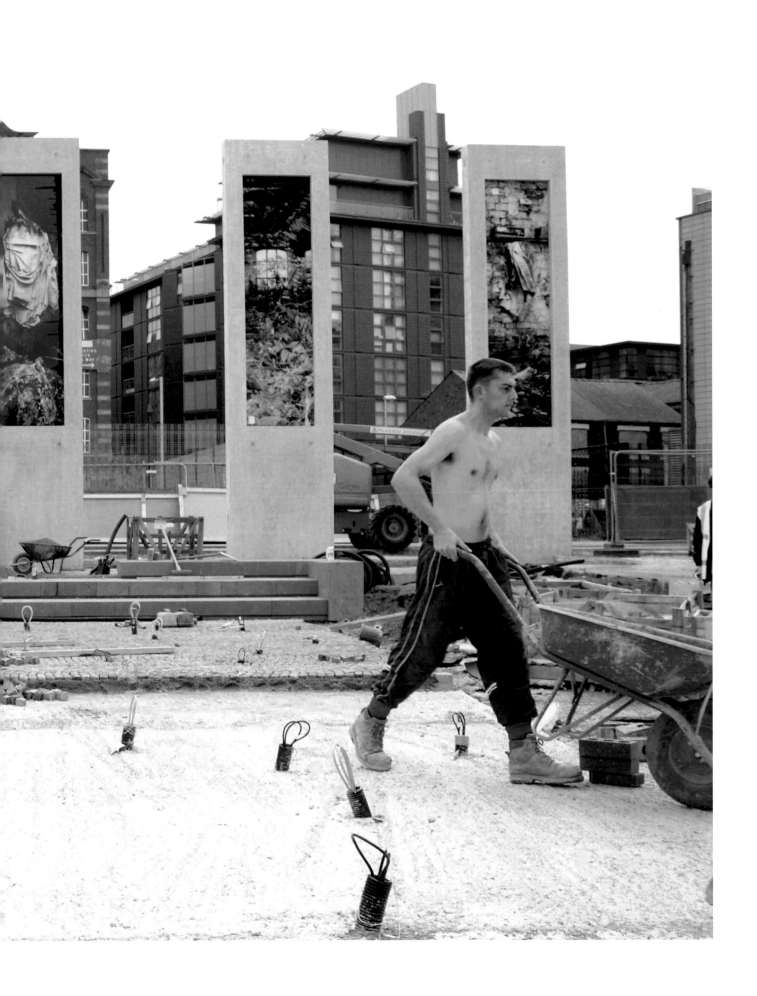

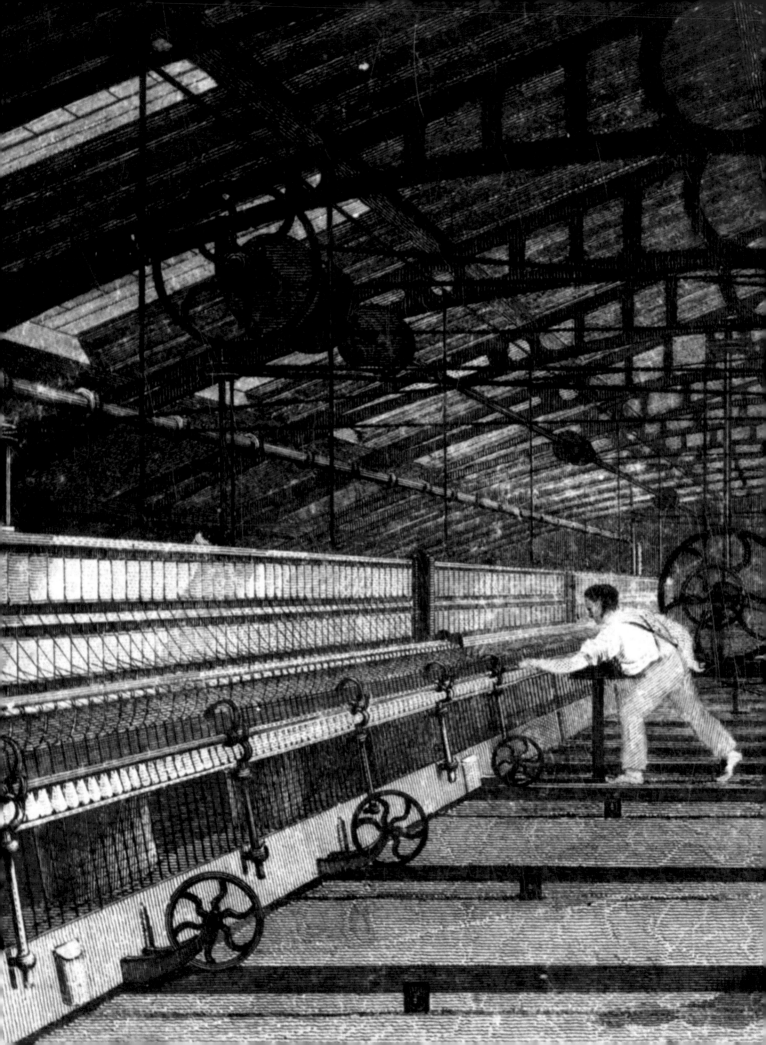

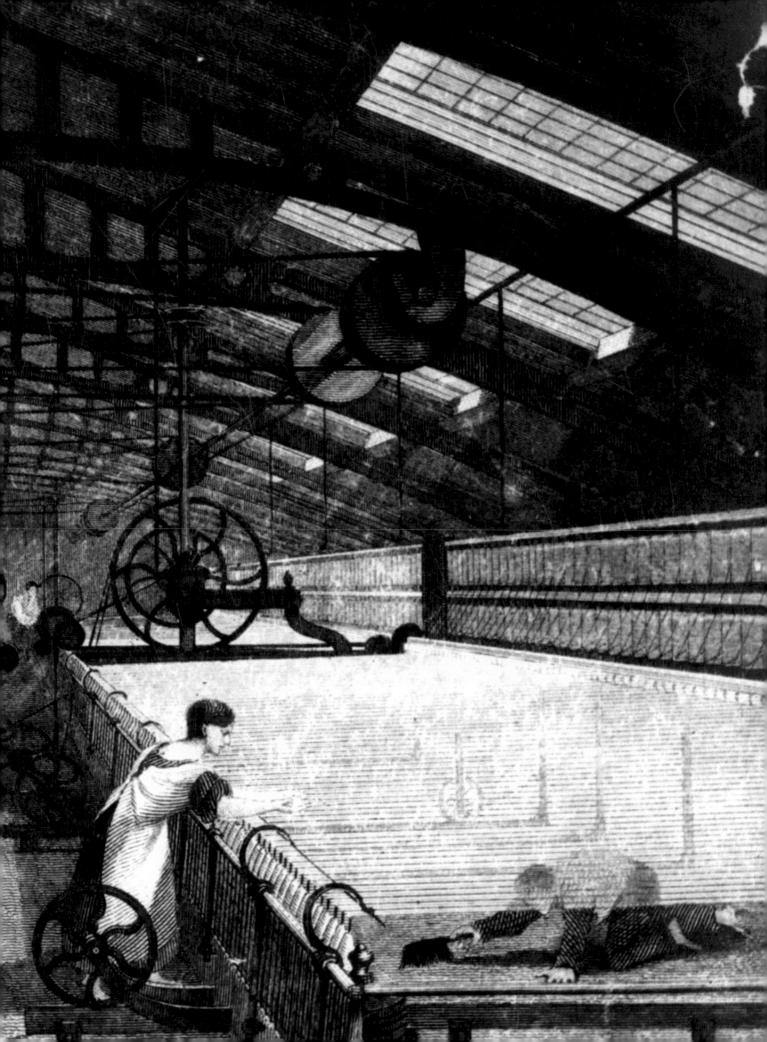

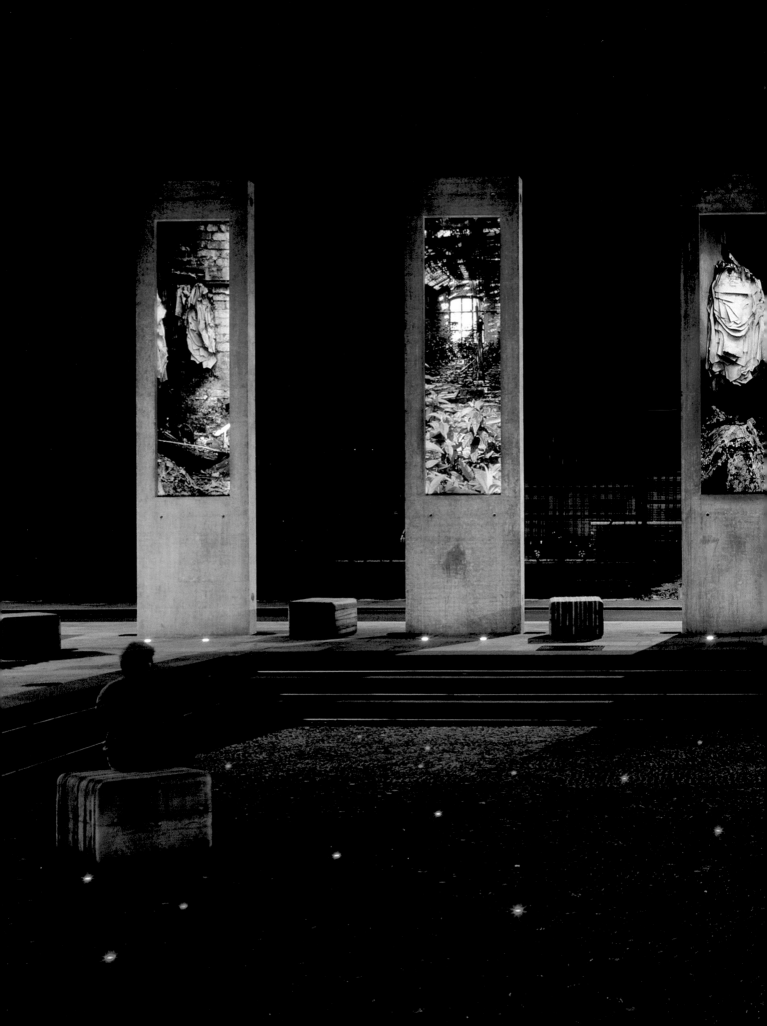

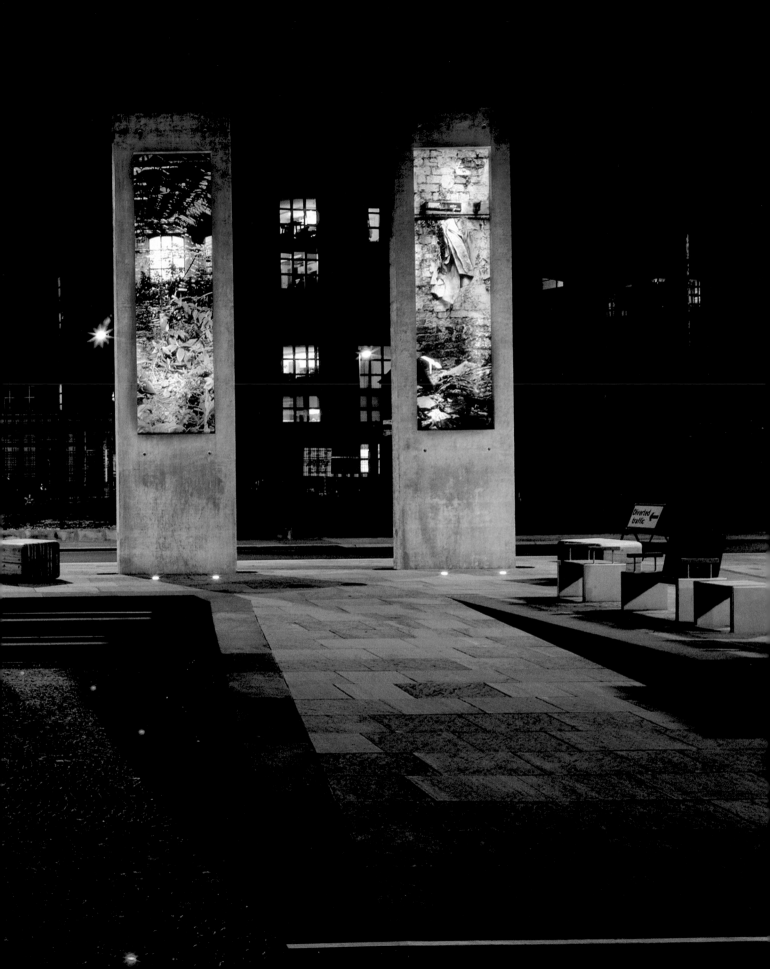

The new public square in Ancoats is framed by a series of tall sentinels cast in copper concrete each encapsulating a fragment of a photograph of the last pattern and cutting room in Ancoats. At dusk the photographs come into focus and project an echo of what once defined Ancoats but no longer makes it what it is today.

The emergence of a new square and a place to congregate within the grid of this industrial suburb speaks of what Ancoats is becoming.

By 1851 Ancoats was an established industrial suburb, with 18% of the city of Manchester's population. There were no parks, squares, broad avenues or even trees. Social space was confined to pubs, church, school and the hospital. It is a paradox that with such a dense and poor population, the streets appear so clean and clear in old photographs.

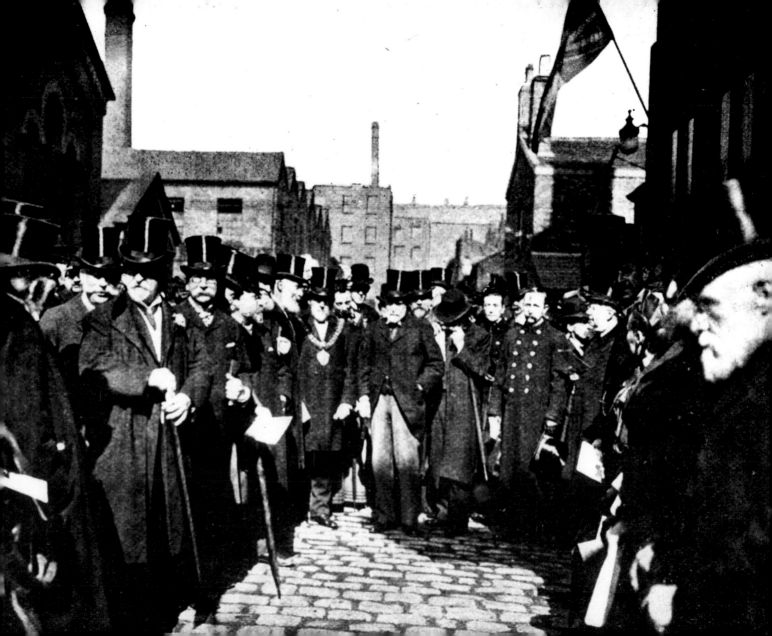

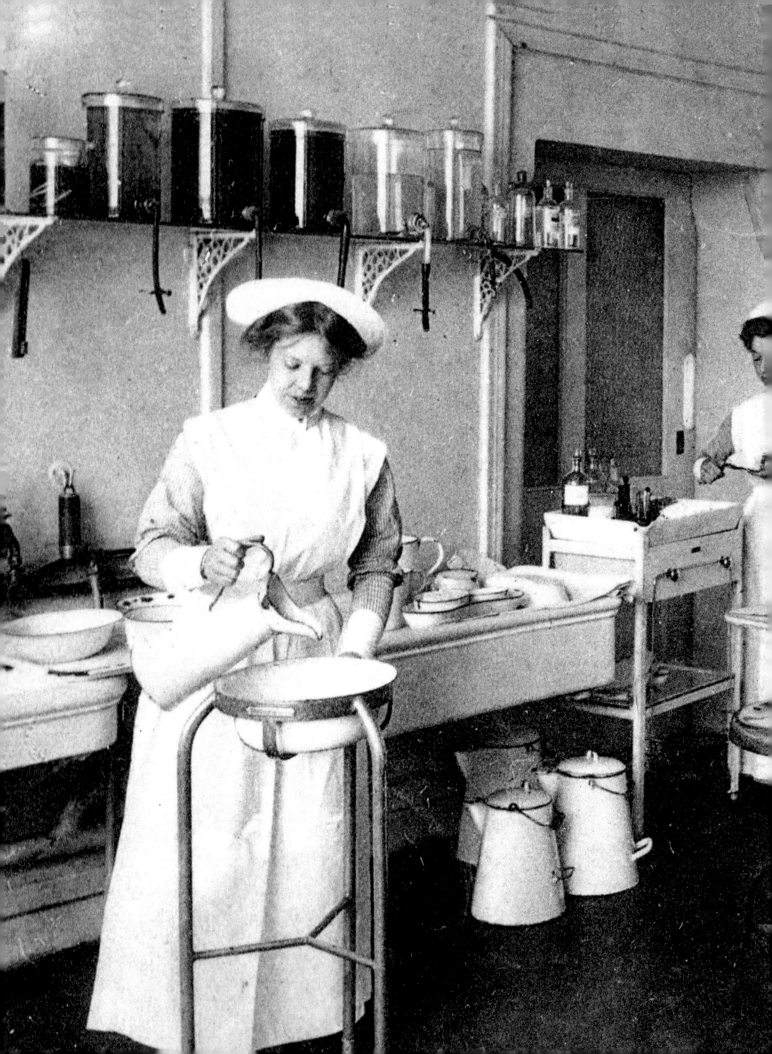

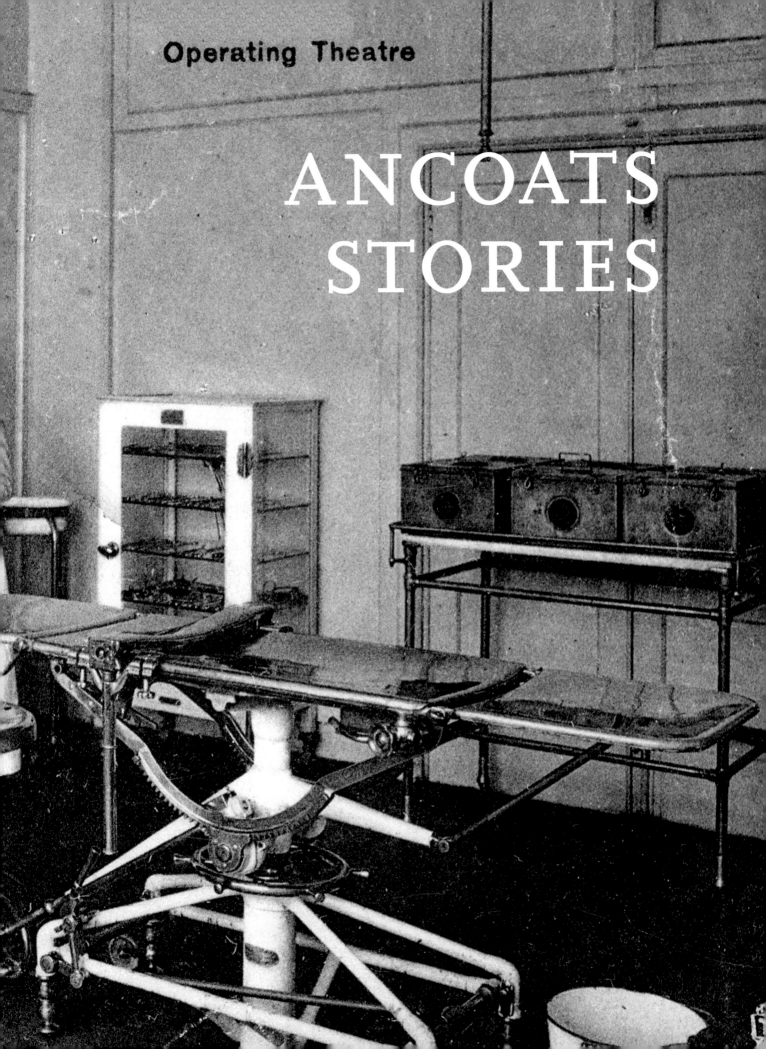

Ice-cream maker's story

My dad and his brothers had an ice-cream factory in Ancoats, Marco's. It was based on Old Street which was just off Jersey Street, Blossom Street there.

This particular Saturday afternoon, me Dad's making the mix. He's doing a boil and he was making something like 300 gallons of milk, which was quite a lot of milk in those days to produce for a family business of eighteen vans.

He's up on the platform cleaning the cooler.

Silly old me, silly arse, started to clean the floor in the factory. I got all the toxic materials, chemicals to clean the floor. I put dairy milk stone, I put bleach down. I put Vim down. I put Fairy Liquid down. I put everything down that was a cleaning agent, even Jif.

I didn't realise what I had created. And I was heaving myself. I was going 'Heeuuum peuuf!' I was brushing away – 'Heeuum peuuf!'

All of a sudden I heard this mighty crash, and I heard this voice come out and it said:

'You fucking silly bastard!'

And I thought:

'Eh?'

And I'm still heaving and I'm dying with the fumes.

'You've made fucking mustard gas!'

It was me dad.

'Get out!' he said. 'Get out of the factory, just get out into the street!' And he's opening all the doors, he's putting all the fans on, to take this poisonous gas out.

We get into Wood Street and he chased me all the way up Wood Street, onto Cotton Street back up Jersey Street and onto the side near St Peter's Church. We was running round like two nutcases.

And me uncle Alf and me uncle Tony comes rolling up with the ice-cream van – he'd forgot a box of flakes. He said 'What the hell's wrong?'

And me dad said, 'It's that daft bleeder. He's nearly killed me!'

He said, 'I've fell off the cooler!'

He said, 'I've smashed all me hand!'

He said 'I've smashed all me leg!'

He said, 'He's so and so stupid! I've told him time and time again. Ask me! Ask me before you do anything.'

He said, 'I've told him, go and piss off to your mother where you look the best, don't come here to murder me!'

He said, 'I've got a business to run.'

By 1815 Ancoats was the most densely populated part of Manchester. Bearing in mind the mills occupied most of the land mass, this infers a much greater density and overcrowding.

In 1851 there were over 50,000 people but by 2000 barely 500 residents remained.

Although celebrated as an Italian quarter, the census in 1851 indicates that 50 percent of adult men had been born in Ireland; a wave of immigration caused by the potato famine.

Ancoats has been one of the UK's principal destinations for immigrants; Italian and Irish arrivals escaping poverty were followed later by Jewish and Pakistani communities.

By 2000 the Italian, Irish, Jewish and Pakistani communities had all long since established their independent community strongholds in other quarters of Manchester.

The Ancoats Nurse

A lot of the people we saw at Ancoats, really, were people with chest conditions; I should imagine, you know, from inhaling the dust and such things in the mills. There was a lot of bronchitis, a lot of really, really serious chest and heart conditions.

But there were also people who came in who had diet deficiencies. I remember people coming in with rickets. Not a lot, but I do remember them clearly, and I remember seeing quite a lot of them walking around the streets of Ancoats. Now, you don't see that anymore, but it's a memory that I have.

The men I nursed at Ancoats were absolutely fantastic. Jolly, cheerful, in no way crude, but just lovely, lovely men who came in to be treated and enjoyed the experience and went out cured, you know, to a large degree.

Less well known than the icecream makers in Ancoats were the Italians who made mechanical street organs. Ancoats was a world centre for their production. Not only were they designed and manufactured in Ancoats, original music was also composed to be played on them. Mancini is perhaps the best known. He might have 10–15 organs in his shop mounted on barrows available to hire to pedlars by the day.

Some organ grinders owned their own barrel organs, others would rent them from the Mancini or Marrocca families on Jersey Street. The hire charge for an organ was about one shilling and seven pence per day. According to records the organ grinder earned up to six shillings per day.

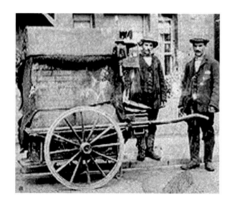

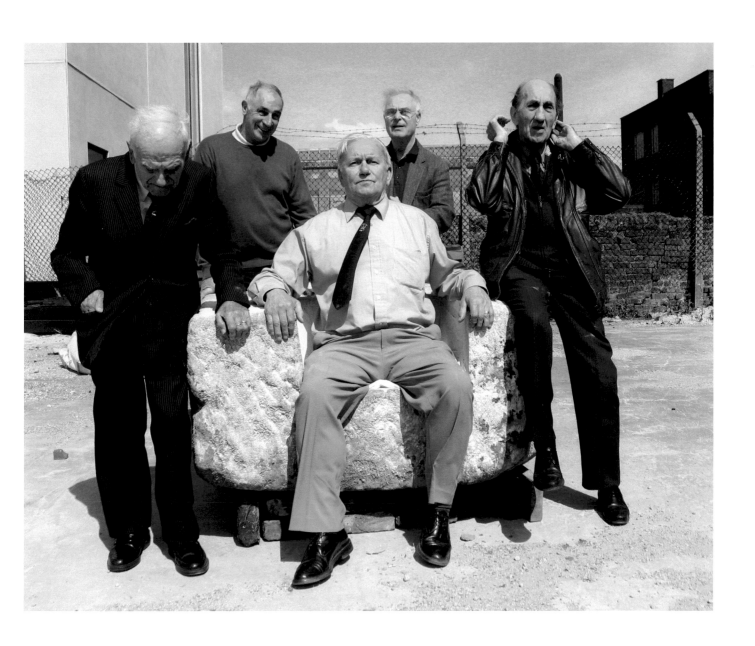

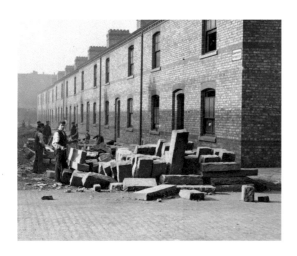

Start digging in Ancoats
and soon you will stumble
across what have become
known as Ancoats stones.
Giant worked stones, they
have strange insets and
irregular square carved
holes. Most likely footings
for machines, they also
appear to have been a
form of foundation stone
laid with ceremony by the
burghers of Ancoats.

As they came to the surface
during the various building
projects in 2000-2010 a
stone yard was made for
collating them, and to make
them available to be built
back in to the streets and
buildings.

A cultural masterplan rests
on the foundation of finding
a way for a project to grow
out of a place. What should
it build on and how?

Doing something
constructive with the
hidden spaces discovered
in the area was one of
the corner stones of
establishing a new public
realm in Ancoats.

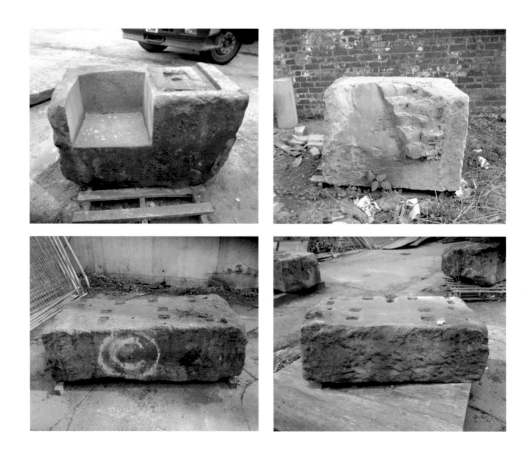

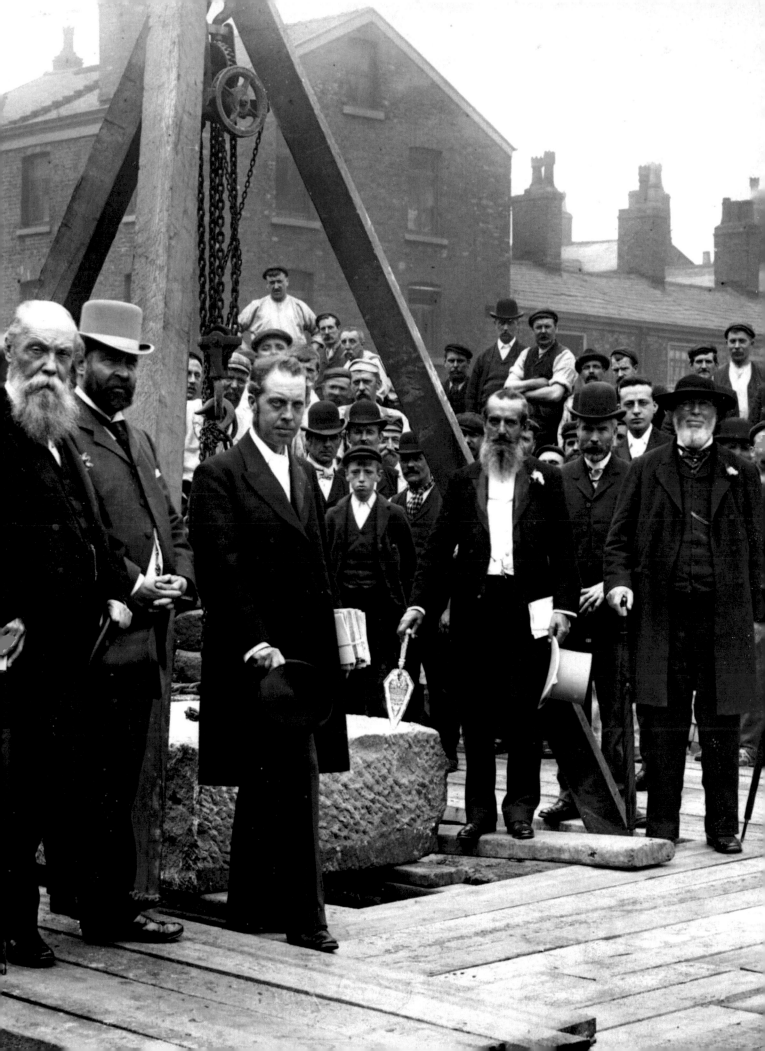

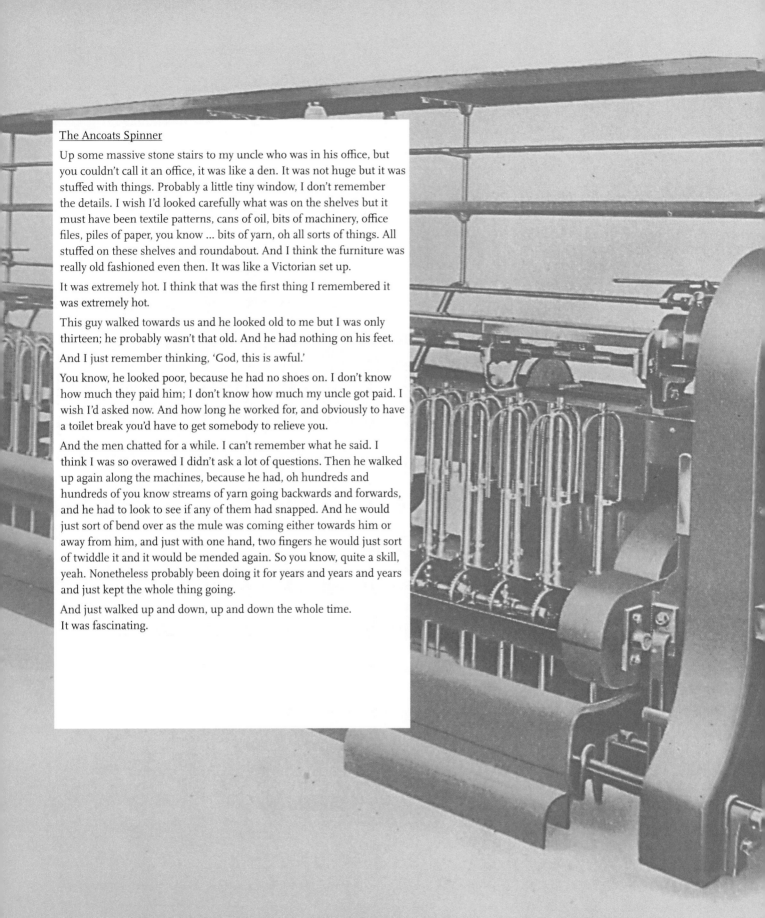

The Ancoats Spinner

Up some massive stone stairs to my uncle who was in his office, but you couldn't call it an office, it was like a den. It was not huge but it was stuffed with things. Probably a little tiny window, I don't remember the details. I wish I'd looked carefully what was on the shelves but it must have been textile patterns, cans of oil, bits of machinery, office files, piles of paper, you know ... bits of yarn, oh all sorts of things. All stuffed on these shelves and roundabout. And I think the furniture was really old fashioned even then. It was like a Victorian set up.

It was extremely hot. I think that was the first thing I remembered it was extremely hot.

This guy walked towards us and he looked old to me but I was only thirteen; he probably wasn't that old. And he had nothing on his feet.

And I just remember thinking, 'God, this is awful.'

You know, he looked poor, because he had no shoes on. I don't know how much they paid him; I don't know how much my uncle got paid. I wish I'd asked now. And how long he worked for, and obviously to have a toilet break you'd have to get somebody to relieve you.

And the men chatted for a while. I can't remember what he said. I think I was so overawed I didn't ask a lot of questions. Then he walked up again along the machines, because he had, oh hundreds and hundreds of you know streams of yarn going backwards and forwards, and he had to look to see if any of them had snapped. And he would just sort of bend over as the mule was coming either towards him or away from him, and just with one hand, two fingers he would just sort of twiddle it and it would be mended again. So you know, quite a skill, yeah. Nonetheless probably been doing it for years and years and years and just kept the whole thing going.

And just walked up and down, up and down the whole time.
It was fascinating.

FRONT VIEW OF ROVING FRAME.

The Ancoats Settlement

Now in Ancoats, children … I'm going back to the war because it affected me tremendously; …

And then the children of my age group and plus ran a campaign through the streets one night in Jersey Street here, where the windows of a few houses were broken. So I went out on the street. And I always remembered this lad who lived in Jersey Street dwellings here. And he come up. He was about two years older than me.

So we settled it in this way … and it became traditionally 'The Place of Settlement' – and it's still here, that's that bridge there, across the canal. If you go up the steps you'll notice a flat area on the top.

So the kids, the children of the village, when they'd been to school dinners at St James the Less old church there, they used to come back and smother the seats, the steps on both sides. And Cyril Brown, who was the nephew of the great world champion Jackie Brown, used to referee the fights. Sometimes there'd be about four fights in the afternoon. Settlement!
Weren't allowed to fight in the streets. We did it on the Queensbury rules situation on the top there. It was tremendous it was!
So I got this one, a lad called Joe Drew. Big lad. He was easily four inches in reach better than me. And he come out there with his left hand forward.
So I walked up to him and I said, 'Joe, just let's be friends.' And as he puts his hands down, I hit him on the chin! So Cyril Brown disqualified me. But I got away with it, didn't I? Bang! Right on the chin I hit him!
So it was a settlement, you see. And this was the way life was in the area.

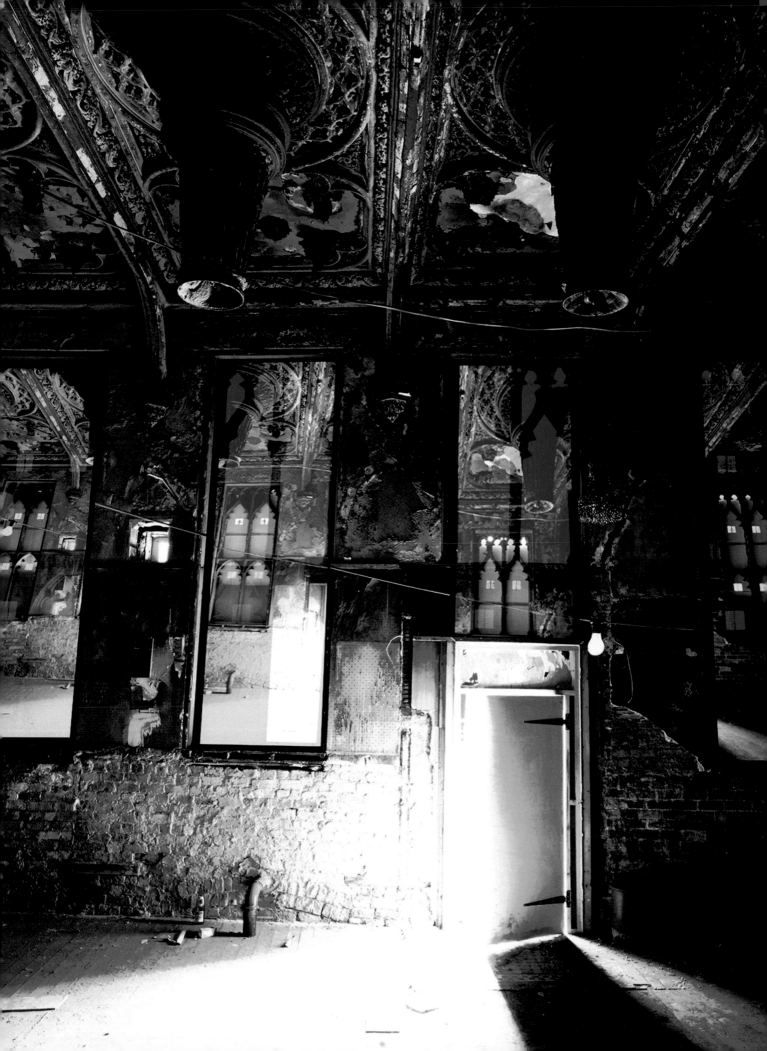

The Crown and Kettle

On the corner of Oldham Road and Great Ancoats Street, one of Manchester's main cross roads, is the Crown and Kettle Pub. It is said that this pub was originally intended to be a court of law; its elaborate interior speaking of grander uses. Local myth and fact have a tendency to live side by side in Ancoats, no less on this particular site. Did public hangings take place outside at the crossroads? Were riots about the Irish potato famine and other social protests played out on its doorstep? The walls are hung with panels. Were these really recovered from an airship which caught fire and crashed? The rich web of history and myth lend the building an opaque yet more substantial presence in Manchester.

Nestled into the sprawling black glass-walled Express Newspaper building complex with its twin sisters in London and Glasgow, in more recent times the pub has served as a favourite jaunt for journalists covering the North West. But the Express left in the mid 1990's, and the journalists with it. The Crown and Kettle was later boarded up following a fire but has recently opened again as a pub. What new myths will breed there next?

PUB NAMES
Shamrock Inn, Bengal Street
Smith's Arms, Sherratt Street
White Swan Inn, Bengal Street
Rose and Crown, Ancoats Street
The Admiral, Rodney Street
Church Inn, Jersey Street
Crescent Inn,
Great Ancoats Street
Cross Keys, Jersey Street
King's Arms, Ancoats Lane
Crown Hotel,
Great Ancoats Street
The Dancing Weasel,
Great Ancoats Street
The Green Dragon,
George Leigh Street

The Ancoats Blob, also known as 'all-ins', was apparently the downfall of many a strong man (and woman) and seems to have been the early version of a cocktail of very strong alcohol with everything in it – a couple of them and you were ready to fight right up to the point you passed out and lost your vision, akin to absinthe and strong gin. Articles were written about the dangers of the Ancoats Blob expressing concern about the way it was literally demoralising people. This lead pretty directly to the construction of both the men's hostel and the women's shelter complete with cocoa house on the ground floor in Ancoats, providing the fallen men and women with a shelter and something other than the demon drink.

"The tabernacle at Oldham Road is one of the best attended of any in town, it is situated in a densely populated and very drunken neighbourhood.....The spirit of the cause is more lively here than in many other places owing to excitation kept up by the officers."

From *Methodist Secessions: the origins of Free Methodism in three Lancashire towns.* D.A.Gowland, p.159

The Ancoats Singer

The day I was born, me grandmother, me mother's mother, was very ill
in bed. And me mother took me down to see her. And me grandmother
says to me mother;
'Go out, our Nelly, and go down to the pub and have a singsong and let
them people enjoy themselves, cos they all love you, truthfully.'
She took it to heart, cos she done it every night!
But we loved me mamma. You know what I mean? If mamma wasn't
in the house there was something missing.

Well, dad says to mum this night (cos mum always went out) he says;
'Lady, you won't cross that door tonight!'
She says, 'I'm not going anywhere.'
So she goes in the kitchen and she hung her coat behind the door.
And he says, 'So, what you doing in there?'
She says, 'Well I'm just going to put the kettle on for a cup of tea.'
Which was unusual because we always had a big black kettle on the
hob. You know, everyone did, you had a big black kettle on the hob.
You always had boiling water. And she (mam told us this, you know)
she turned the tap on - there weren't a great pressure - and she hung
the kettle on the top of the tap. Coat on, and out! And she was out in
the 'Church' singing her head off!
The old fella was looking in all the other pubs baring the 'Church', cos
the 'Church' was her pub, and the thought was; 'She won't be in there.'
Of course she was!
And she could sing, me mother, really. They reckon Gracie Fields
wasn't even a match for the old woman; she was really a contralto.

What makes Ancoats Ancoats?

PEEP 13: GOVERNOR FIELD

Archaeologists have developed
the most sophisticated of
methods to interpret the scraps
of what societies leave behind.
Industrial archaeology has
brought to us an examination of
our recent past. Might there not
usefully be a cultural archaeology
of the immediate past? The
interpretation of that which has
not yet been historicised; taking
readings of what we discard as
we discard it.

There is a lot we can understand
about our contemporary society,
about the structures we chose
to abandon and the ruins that
cohabit living cities.

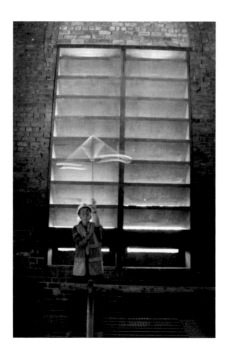

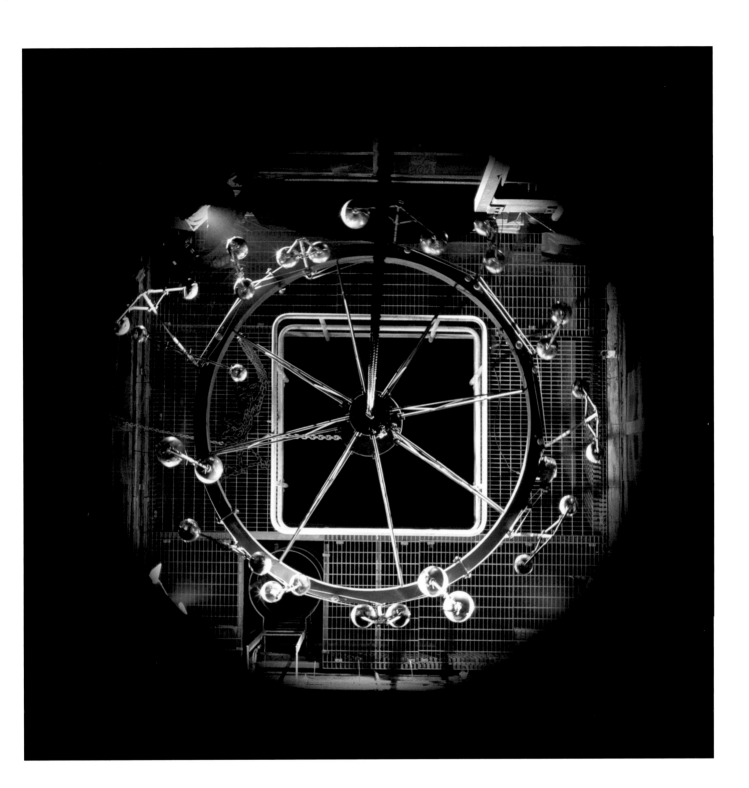

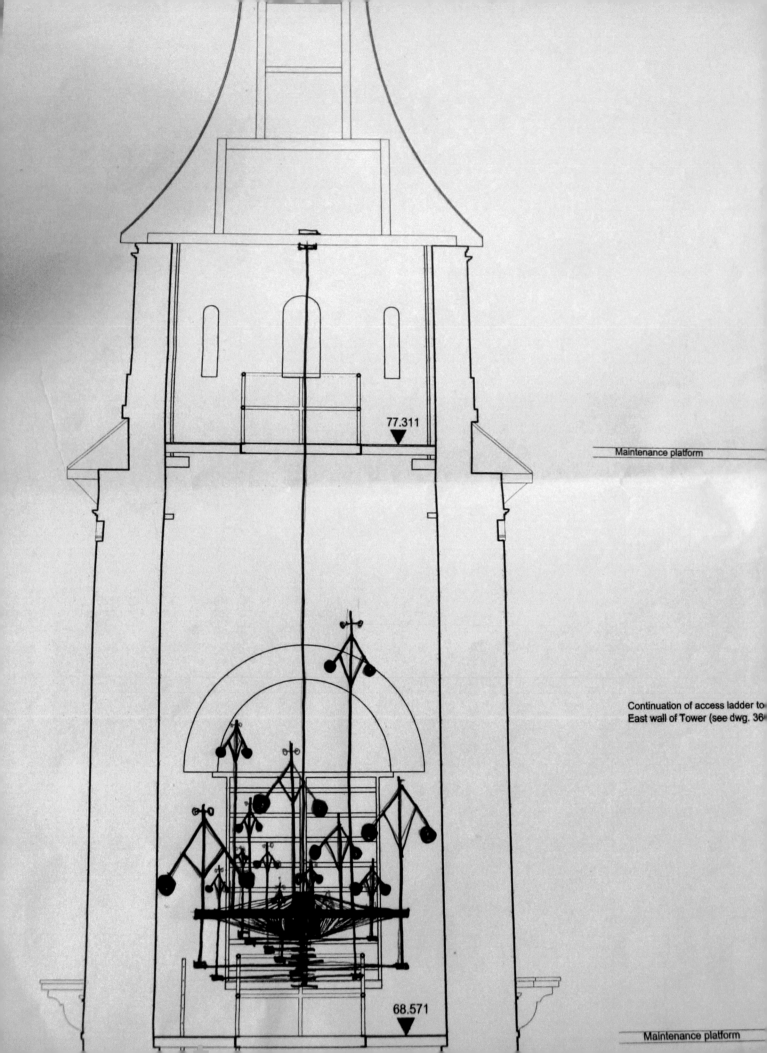

77.311

Maintenance platform

Continuation of access ladder to
East wall of Tower (see dwg. 36

68.571

Maintenance platform

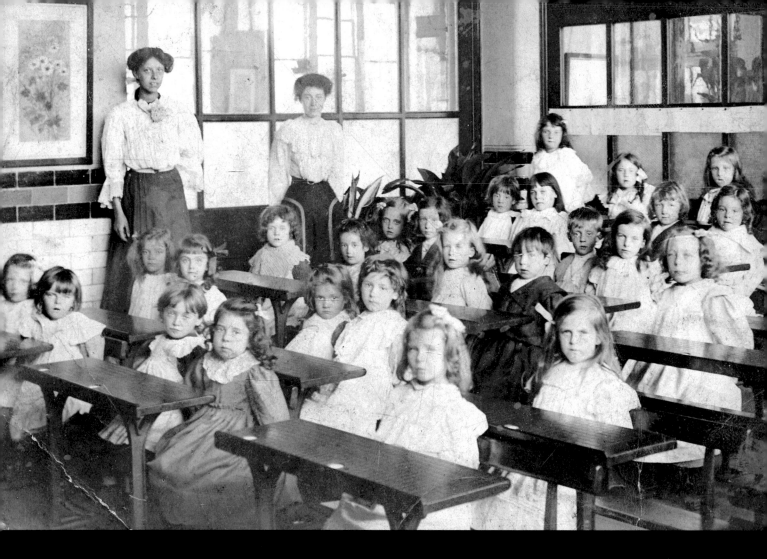

Following the general election in 2010, the UK national urban policy to regenerate inner cities was dismantled, overnight. Ancoats, in the middle of a redevelopment programme, is left once again to make its own way in the world. In 2000 this area was mostly wastelands. Since then it has had a significant leg up and there is a certain momentum.

In 2011 the Hallé Orchestra moves into Ancoats. Already celebrated for its music, this is adding a new dimension and impetus to the identity of the area. There is the sense that the Hallé could play a key part in this new era, contributing significantly to the psyche of the area and its emerging identity. In 2010 I embarked on a collaboration with the Hallé

The players

THE PLAN

Lyn Fenton
Stefan Brzozowski
Martin Stockley/Stephen O'Malley
Paul Shirley Smith/Irina Brune/Robert Camlin
Dan Dubowitz

THE PEEPS

Dan Wrightson
Pickle Ellison
Mary Wardle
Noel Sharkey
David Ralston
Dan Dubowitz

MAKING THE CUTTING ROOM AND THE PEEPS

Pickle Ellison
Pete Kerr
David Ralston
Andy Firman
Davy McCready
Ivan Ellison
Barry Ramshaw
Andrew Scantlebury
Brian Caster
Simon Hopkins
Phil Bell
Mary Wardle
Dan Dubowitz

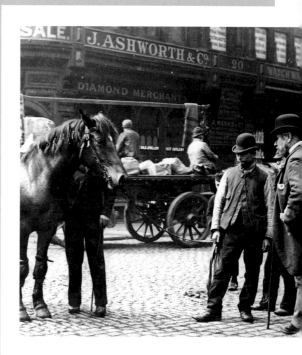

THE CLIENTS

Mark Canning
Lyn Fenton
Helen France
Nik Puttnam
Tom Russell
Eddie Smith

THE FUNDERS

 NEW EAST MANCHESTER

 northwest development agency

 Project Part-Financed by the European Union
European Regional Development Fund

Acknowledgments

A large number of extraordinary people have contributed, in their own ways, to these projects and the remaking of this area. Although it is not possible to mention everyone they are all in some way present in this work. My especial thanks go to:

Ian Banks
Marion Barter
Jim Bell
Cecil Black
Julian Broster
Andy Burrell
Brian Caster
Sylvia Caveney
Jim Cousins
John Cunliffe
Kate Dickson
Serafino di Felice
Graham Dodd
Giuseppe Domenichelli
Nathan Ezair
Jake Ezair
Graham Festenstein
Mark Foxwell
Matthew Frost
Richard Haley
Kerenza Hines
Jeff Ingber
Jean Laurie
Penny Lewis
Steve Little
Neil Logan
Chris McDermott
Angela McKenna
Ian Miller
Nicola Moorhouse
Nicola Mulholland

Diana Naden
Juwad Nayyar
Jonathan Owen
Steve Quicke
Anthony Rea
John Riley
John Robinson
Jan Robson
Graham Russell
Michael Schlinz
Arthur Simpson
Robert Slinger
Simon Stern
Jamie Stones
Virginia Tandy
Diana Terry
Harvey Thorpe
David Vincent
Mary Walsh
Richard Weltman

From 1750s to the late 20th century Ancoats was built from private capital

Ancoats was constructed by the great mill owners and was a product of the geniuses of engineering, and the imagination and ambition of entrepreneurs. It was also the product of the sweat and toil of countless un-named workers without whom Ancoats (and the propulsion of Manchester's influence around the world, and the subsequent wealth generated) would never have happened.

From 1997–2009, it was politics that drove the rise and stall of the area.

The UK developed a national policy that drove the redevelopment of post industrial wastelands like Ancoats.

In 2010 it is politics that has this time halted the regeneration of Ancoats. Following a banking crisis there is a new political direction that has ended this national policy of urban renewal lead by government, and closed down regional regeneration projects. The future of Ancoats is now down to the individuals and organisations who have made a long term commitment to the area, the businesses and tenants who have successfully weathered the long decline and then the recovery when the streets were being dug up, and the people who have moved into the area to live or to develop new businesses.

The future of this fascinating and important part of Britain is in their hands.

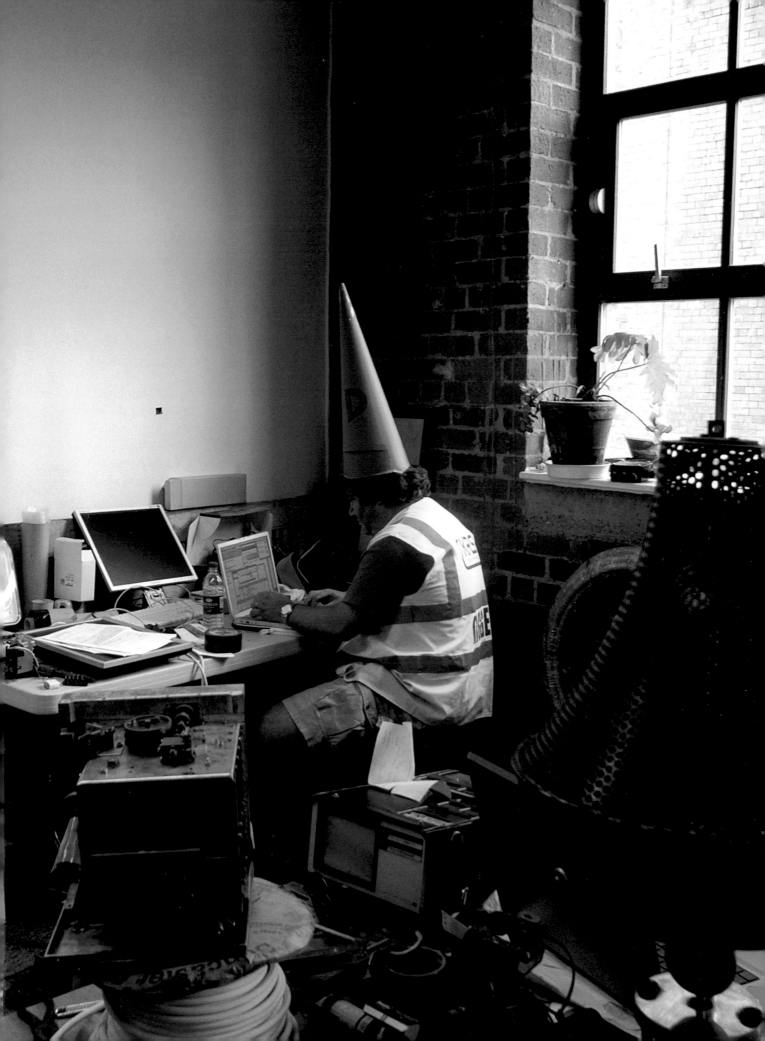

First published 2011 by
Manchester University Press
Oxford Road, Manchester
M13 9NR UK

Distributed exclusively in USA by
Palgrave, 175 Fifth Avenue,
New York, NY 100010, USA

Distributed exclusively in Canada
by UBC Press, University of British
Columbia, 2029 West Mall,
Vancouver, BC, Canada V6T 1Z2

ISBN 978 0 7190 8552 9

In part this book has been made
possible by the generous and
enthusiastic support of the
archivists at Manchester City
Library Manchester Room, and
the County Records Office, who
supported the project from
the research stages, all the way
through to finding images for
the publication.

British Library Cataloguing-in-
Publication data
A British Library CIP record is
available

Peeps photography ©
Dan Dubowitz

Additional images courtesy of:
pages 2, 4, 72, 73, 74, 75
Len Grant
pages 5, 6, 8, 12, 15, 16-17, 18, 20-
21, 24-25, 28-29, 30, 37, 38, 41, 52,
53, 58, 62-63, 66, 68, 78, 84-85,
90-91, 92, 94, 97, 98-99, 104-105,
106, 114-115, 119, 120-121, 125, 127,
128, 137, 138, 140, 141 Manchester
City Council Libraries
page 23 Paul Shirley Smith
pages 33-34, 44-45 Pickle Ellison
pages 34, 40, 71 Oxford
Archaeology
page 42 Singer catalogue
page 46, *La Nature*, 1894
pages 47, 88, 143 Mary Wardle
page 48, *De Natuur*, 1889
page 51 BDP Courtesy of
Ken Moth
page 118 John Fenton
pages 122-123, 124 Tony Rea
page 139 Alan Ward

Additional literary
acknowlegements: p.39,
Mary Wardle. p.42 Robert Reid,
The Peterloo Massacre, 1989,
William Heinemann Ltd.
p.54 Joseph Rykwert, *The Idea of
a Town 1988*, MIT. p.60 Venessa
Bagley, research on Methodist
men's homes. P.65 *Methodist
Secessions: the origins of Free
Methodism in three Lancashire
towns*. D.A.Gowland, 1979, MUP.

Designed and typeset by
Alan Ward
www.axisgraphicdesign.co.uk

Set in **FF Scala** and Scala Sans Pro

Printed and bound by
DeckersSnoeck, Antwerp,
Belgium

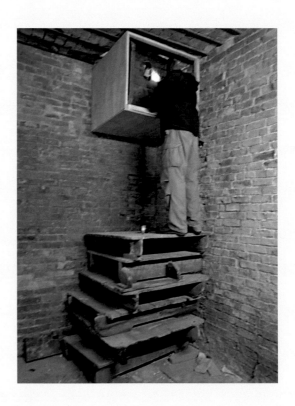

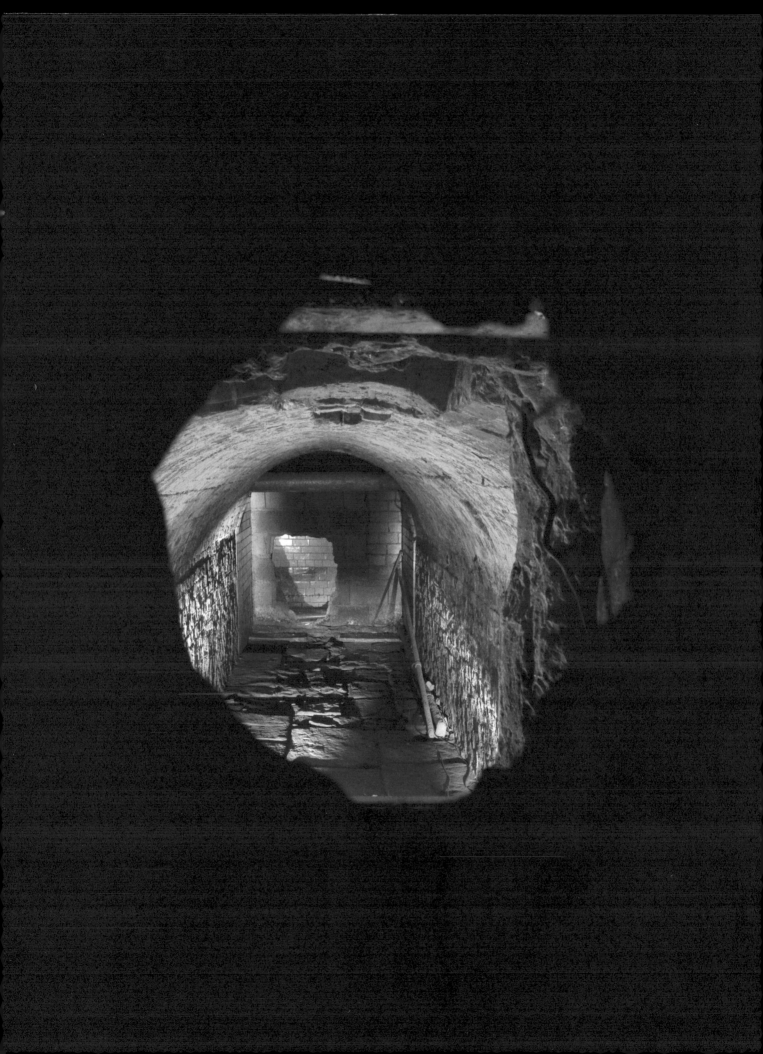